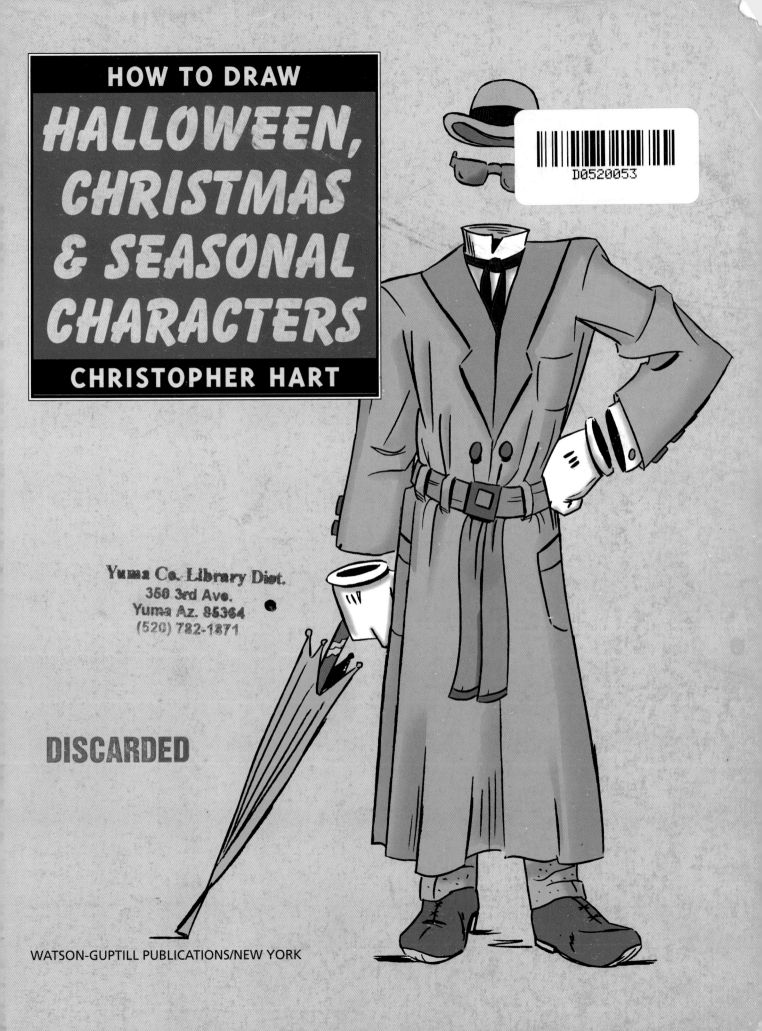

HOW TO DRAW
HALLOWEEN, CHRISTMAS & SEASONAL CHARACTERS
CHRISTOPHER HART

WATSON-GUPTILL PUBLICATIONS/NEW YORK

D0520053

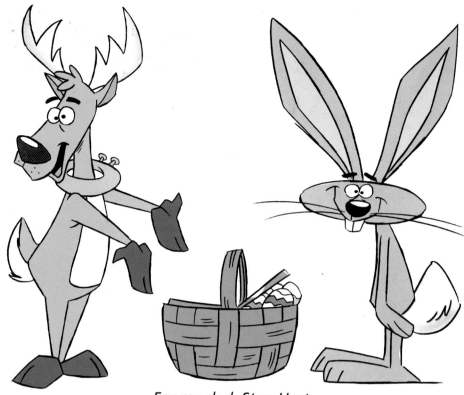

For my dad, Stan Hart

Senior Editor: Candace Raney
Project Editor: Alisa Palazzo
Designer: Bob Fillie, Graphiti Design, Inc.
Production Manager: Ellen Greene

Cover art by Christopher Hart
Text and illustrations copyright © 1999 Christopher Hart

First published in 1999 by Watson-Guptill Publications,
a division of BPI Communications, Inc.,
1515 Broadway, New York, N.Y. 10036

Library of Congress Cataloging-in-Publication Data
Hart, Christopher.
 How to draw Halloween, Christmas & seasonal characters / Christopher Hart.
 p. cm.
 Includes index.
 ISBN 0-8230-2377-X (pbk.)
 1. Cartooning—Technique. 2. Caricatures and cartoons. 3. Holiday decorations
in art. I. Title.
NC1764.H373 1999
743.8—dc21 99-20213
 CIP

Printed in Singapore

First printing, 1999

1 2 3 4 5 6 7 8 / 06 05 04 03 02 01 00 99

CONTENTS

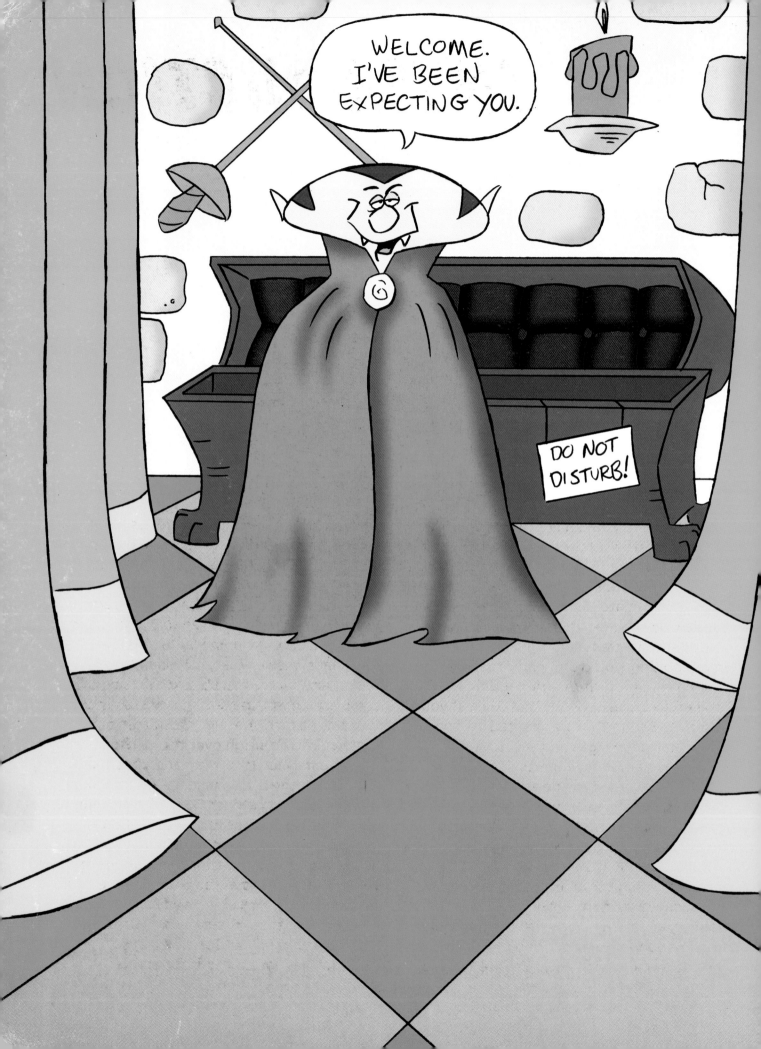

INTRODUCTION

The holidays have always provided cartoonists with fantastic characters for their stories. From Halloween monsters to Santa's elves, countless animated movies and television specials have been inspired by holiday and seasonal characters. And if you're interested in cartooning, you won't want to miss any of them. Animation studios depend on Halloween and Christmas for material—if you doubt it, just go to the animated section of your local video store and see how many titles feature holiday themes. It's truly amazing. Holidays also provide a treasure trove of characters and ideas for comic strip and greeting card artists, children's book illustrators, and of course, toy designers.

Halloween boasts a famous cast of characters—including vampires, devils, zombies, werewolves, mummies, hunchbacks, witches, goblins, and many more—all of which you'll find in abundance in this book. I'll show you the tricks to drawing eerie haunted houses (they should be at least two stories high), vampire's castles (they should perch atop cliffs overlooking the sea), and much more.

The perfect counterbalance to Halloween is Christmas, with all of its charm and warmth. You'll learn how to draw all the jovial Christmas characters, including Santa, his elves, Mrs. Claus, the reindeer, carolers, snow fairies, and more. There's also a section of complete Christmas scenes, as well as important tips on drawing such classic scenes as Santa riding his sleigh over the rooftops.

In addition to Halloween and Christmas, there are many other holidays—from Valentine's Day to St. Patrick's Day, Thanksgiving to Easter, and even Groundhog Day—that have inspired popular characters. Holidays provide us with fun and inspiration throughout the year, so whether your aim is to improve your cartooning technique and add to your repertoire of characters, or simply to create a project for your family or for a class of students, this book has something in it for you.

BASIC POINTERS 'N' STUFF

Before we start drawing all the characters, it's a good idea to go over a few fundamentals. These basic drawing principles are used by everyone, from beginners to seasoned professionals. Try to incorporate them into your work. You'll find that your characters will look more three-dimensional and appealing.

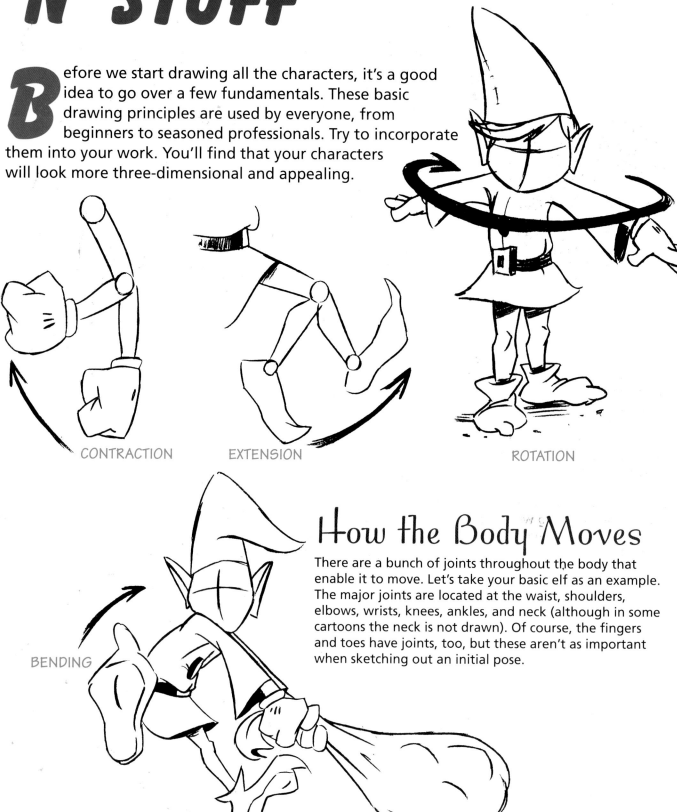

CONTRACTION

EXTENSION

ROTATION

BENDING

How the Body Moves

There are a bunch of joints throughout the body that enable it to move. Let's take your basic elf as an example. The major joints are located at the waist, shoulders, elbows, wrists, knees, ankles, and neck (although in some cartoons the neck is not drawn). Of course, the fingers and toes have joints, too, but these aren't as important when sketching out an initial pose.

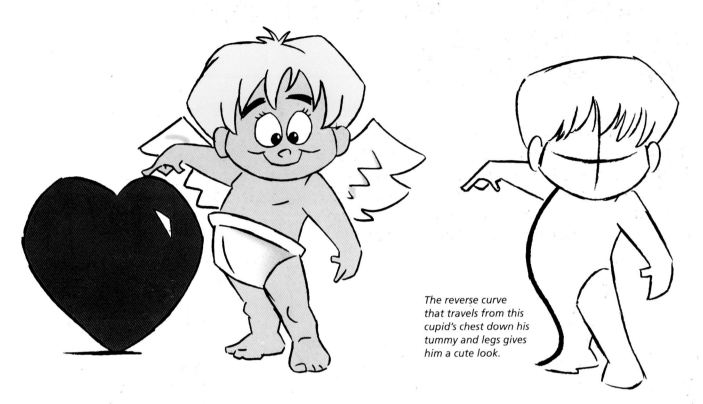

The reverse curve that travels from this cupid's chest down his tummy and legs gives him a cute look.

The most pleasing line in any drawing and on any character is what I call a *reverse curve.* It's a curving line that, instead of continuing into a circle, reverses direction and starts to curve the other way, like the letter "S." For some reason, the eye is drawn to the reverse curve—it is like a water slide for the eye. The eye just wants to travel down that path. You get a subliminal good feeling when looking at a character that is created with reverse curves.

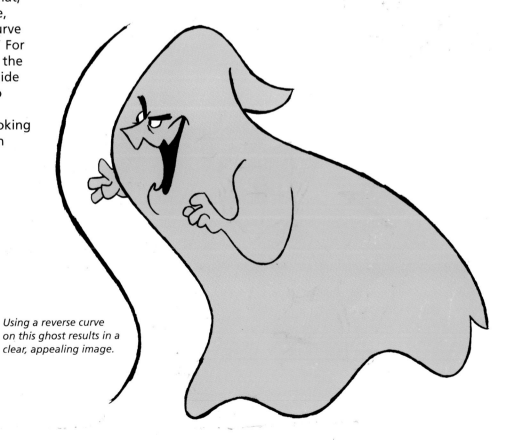

Using a reverse curve on this ghost results in a clear, appealing image.

Lines and Shapes

USING DIFFERENT TYPES OF LINES

Many people think cartoon images are all made of round lines, but that's not necessarily the case. You need to incorporate a variety of lines into your drawings to create interesting characters. Characters that are round everywhere tend to look extremely young and childish. More experienced cartoonists combine both straight and curved lines with sharp angles.

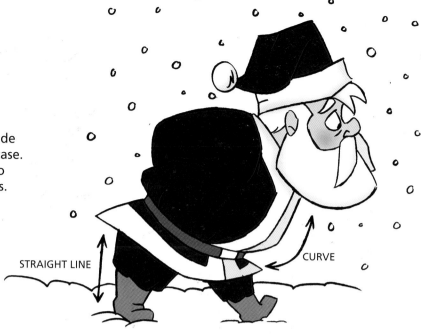

STRAIGHT LINE

CURVE

SHARP ANGLE

SHARP ANGLE

SHARP ANGLE

LOOK FOR HIDDEN SHAPES

Many complex-looking cartoons are really made up of simple, basic shapes. By keeping it simple, you keep it pleasing.

Choosing the Best Pose

Here's our little elf again to demonstrate the difference between an ordinary pose and a catchy, interesting one. When choosing a pose, try to exaggerate it. If your character is sitting, show him really sprawling out instead of sitting stiffly in the chair. If he's pointing at something, make him really lean in the direction of the action.

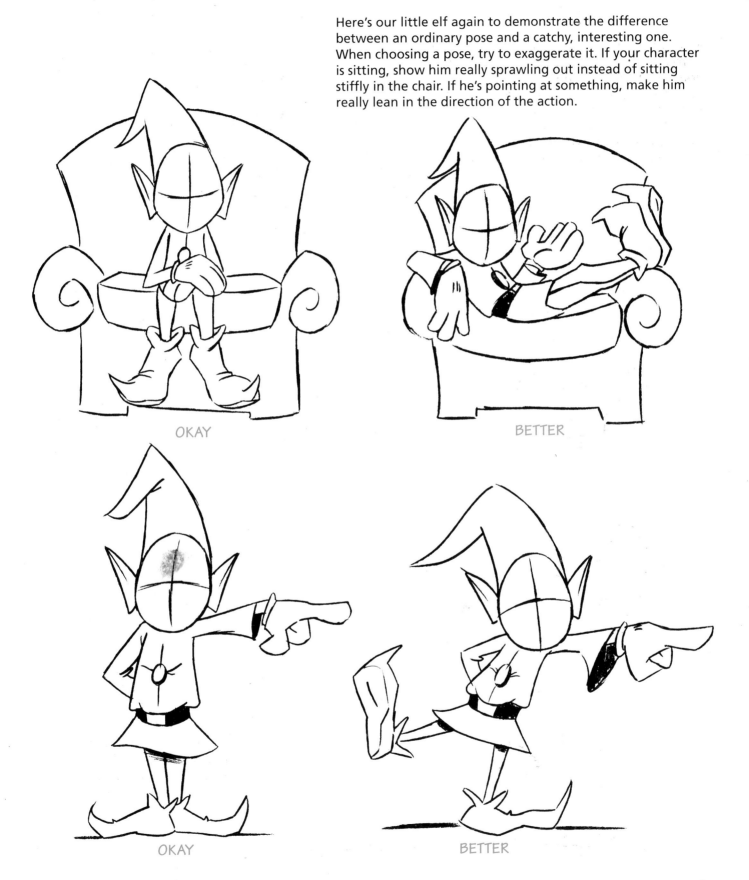

OKAY

BETTER

OKAY

BETTER

Overlapping

When one shape overlaps another, we instinctively assume that the overlapped shape is further away. This is a basic principle of perspective. Artists use it when composing scenes, but it is also very useful when drawing the body. The parts of the body that are nearer to you should *overlap* the parts that are farther away. This will prevent your characters from looking flat.

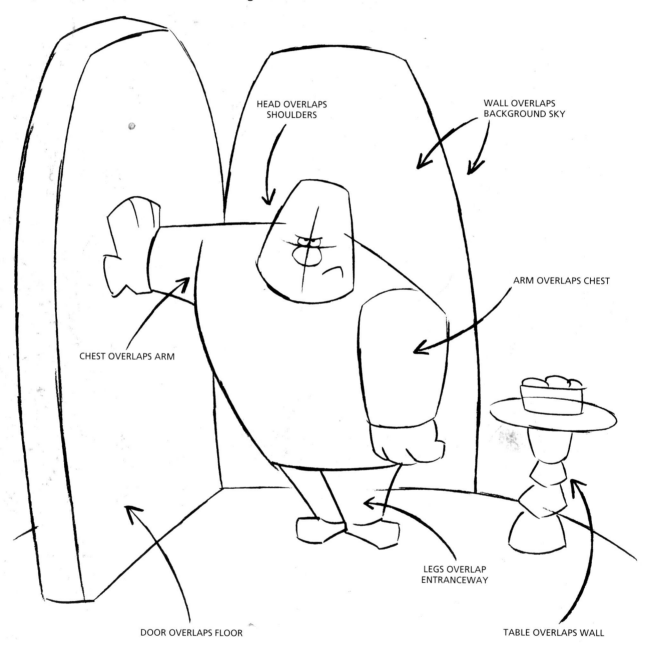

HEAD OVERLAPS SHOULDERS

WALL OVERLAPS BACKGROUND SKY

ARM OVERLAPS CHEST

CHEST OVERLAPS ARM

LEGS OVERLAP ENTRANCEWAY

DOOR OVERLAPS FLOOR

TABLE OVERLAPS WALL

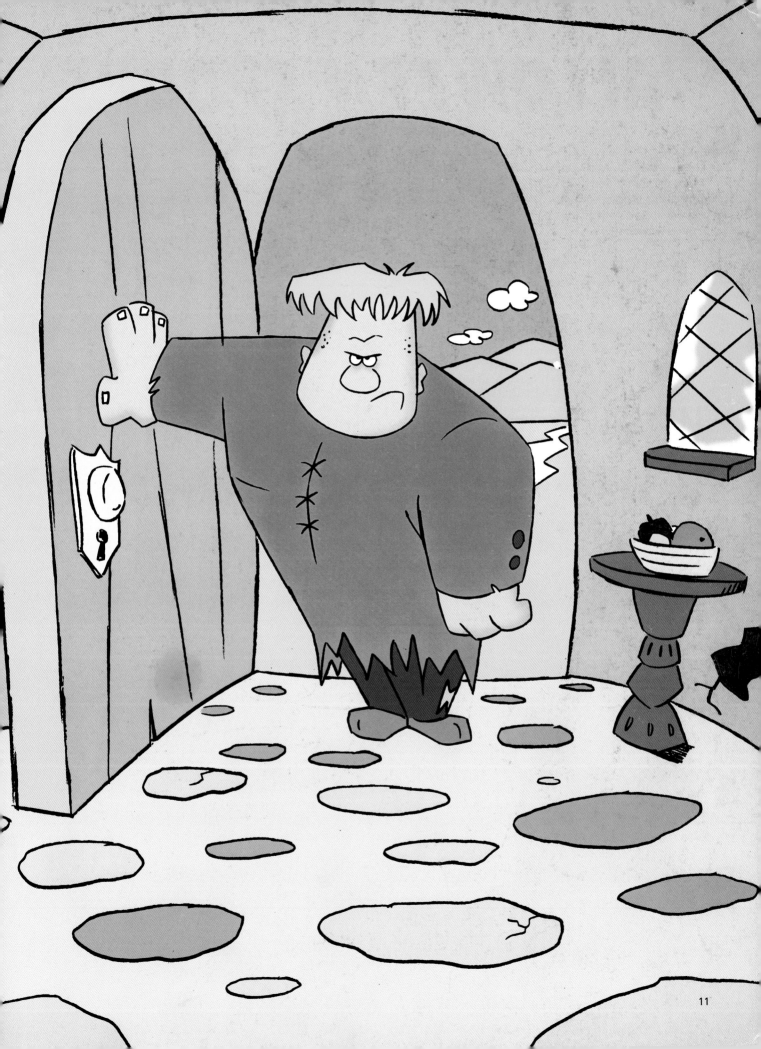

HALLOWEEN SPOOKS

Halloween is one of the most popular American occasions, second only to Christmas for retailers and merchants. Every memorable monster and spooky icon is part of the celebration. But we're not interested in truly scary creatures here, just campy ones. Go for funny, instead of gross or frightening.

Witches

Witches are basically middle-aged women with stovepipe hats, ragged clothes and hair, and really bad orthodontic work.

A WITCH AND HER BROOM

Just like a biker, a witch takes pride in her mode of transportation—her broom. The witch's broom has magical powers, otherwise it wouldn't fly. It's important to indicate these powers when the broom is still earthbound; drawing "energy lines" around it does the trick.

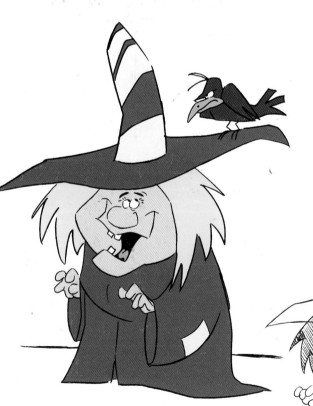

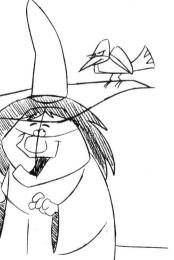

A WITCH AND HER SIDEKICK

Some people have dogs, others have cats. But if you own a pet crow, there's a good chance you're a witch.

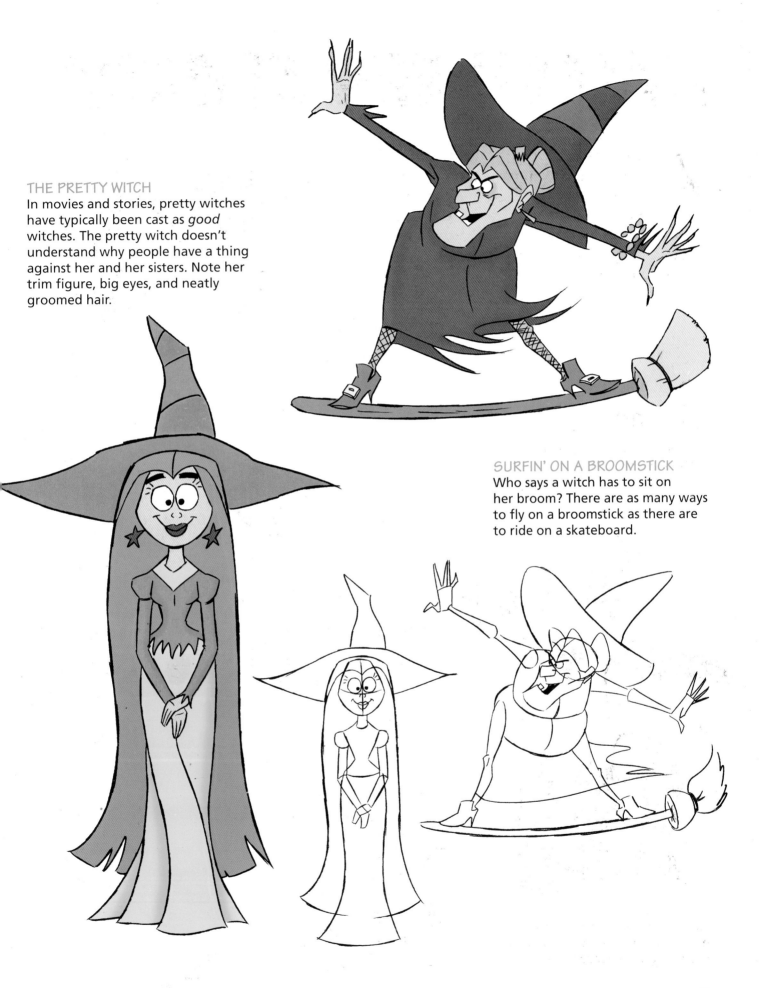

THE PRETTY WITCH

In movies and stories, pretty witches have typically been cast as *good* witches. The pretty witch doesn't understand why people have a thing against her and her sisters. Note her trim figure, big eyes, and neatly groomed hair.

SURFIN' ON A BROOMSTICK

Who says a witch has to sit on her broom? There are as many ways to fly on a broomstick as there are to ride on a skateboard.

Vampires

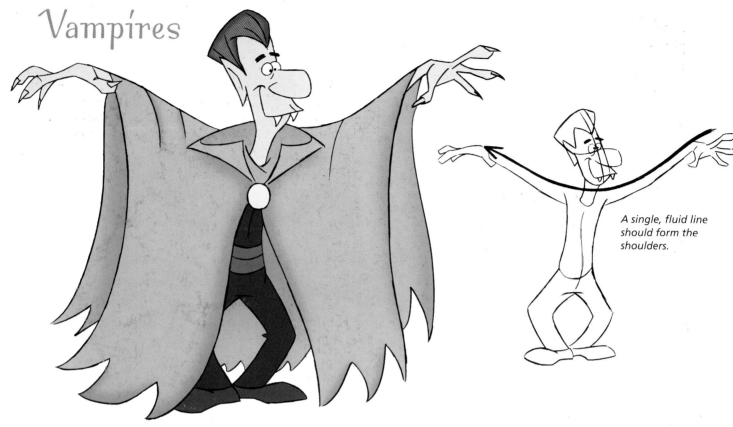

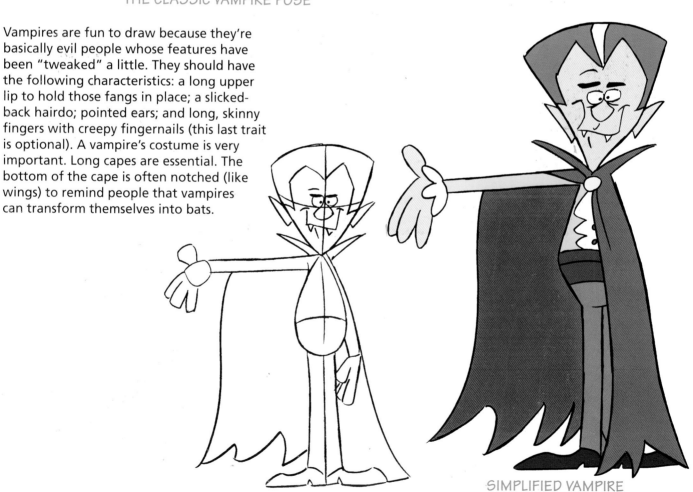

A single, fluid line should form the shoulders.

THE CLASSIC VAMPIRE POSE

Vampires are fun to draw because they're basically evil people whose features have been "tweaked" a little. They should have the following characteristics: a long upper lip to hold those fangs in place; a slicked-back hairdo; pointed ears; and long, skinny fingers with creepy fingernails (this last trait is optional). A vampire's costume is very important. Long capes are essential. The bottom of the cape is often notched (like wings) to remind people that vampires can transform themselves into bats.

SIMPLIFIED VAMPIRE

The Female Vampire

The female undead are just as evil as their male counterparts. Long, creepy hair is an important feature. And the long, tattered sleeves keep her looking delightfully wicked. Crescent-moon earrings add the finishing touch.

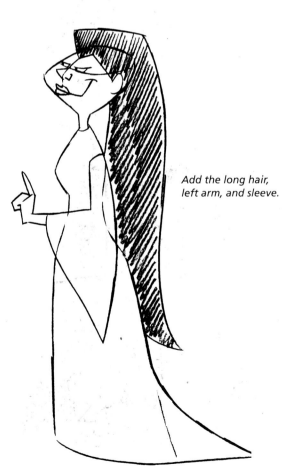

Start with the basic shapes: a rounded teardrop for the rib cage and a circle for the hips. Always draw the entire head without hair first.

Add the long hair, left arm, and sleeve.

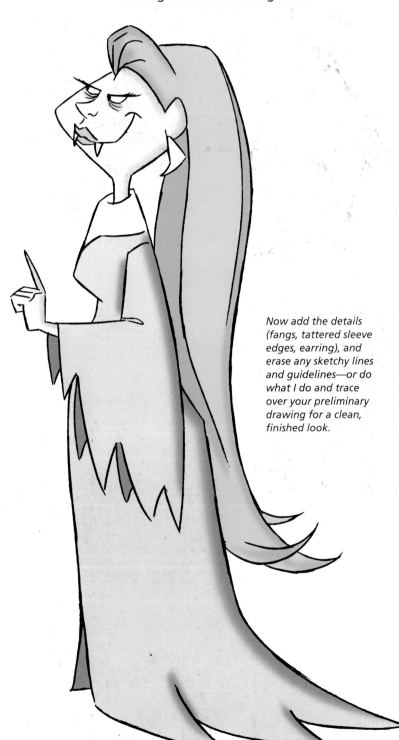

Now add the details (fangs, tattered sleeve edges, earring), and erase any sketchy lines and guidelines—or do what I do and trace over your preliminary drawing for a clean, finished look.

This Way If You Please

In order to make a vampire's castle appear remote and foreboding, situate it at the top of a winding road that leads to the edge of a cliff overlooking the sea. Other good touches are some bats flying around the castle turrets and foggy clouds wafting by in the background. The terrain should look rocky and bare, not marshy and lush. This makes escape difficult.

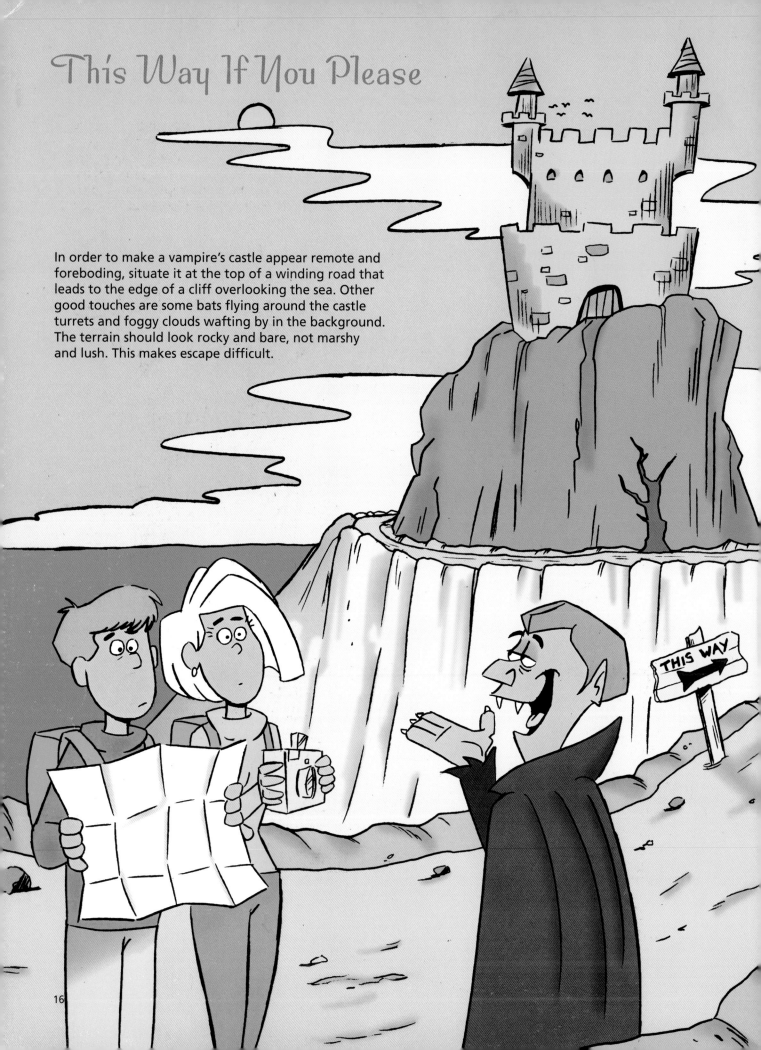

Oh, You Devil!

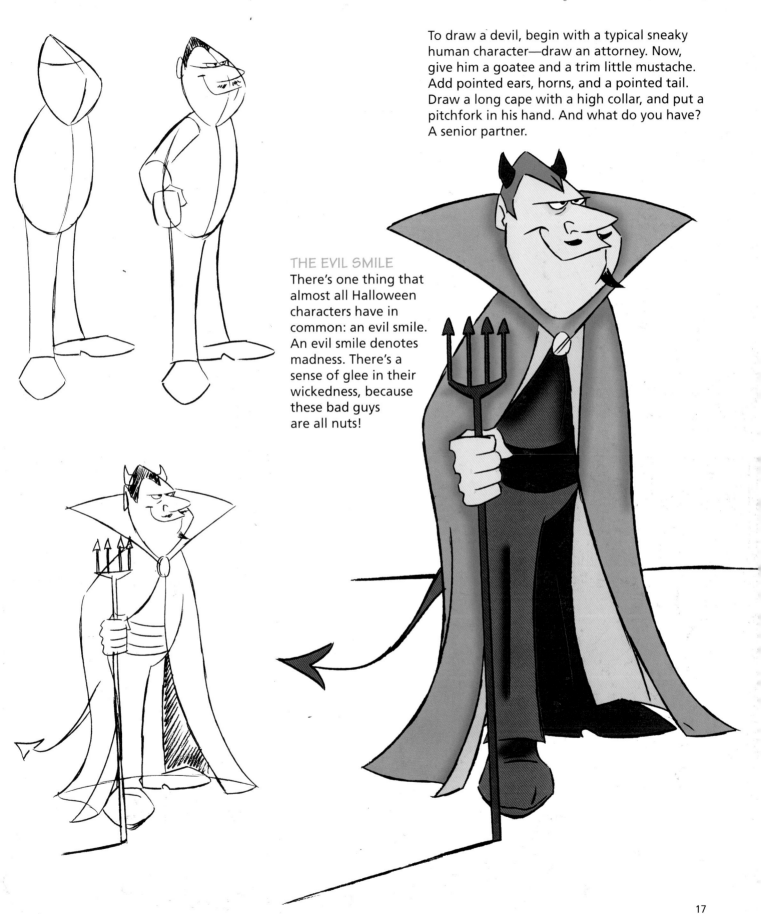

To draw a devil, begin with a typical sneaky human character—draw an attorney. Now, give him a goatee and a trim little mustache. Add pointed ears, horns, and a pointed tail. Draw a long cape with a high collar, and put a pitchfork in his hand. And what do you have? A senior partner.

THE EVIL SMILE
There's one thing that almost all Halloween characters have in common: an evil smile. An evil smile denotes madness. There's a sense of glee in their wickedness, because these bad guys are all nuts!

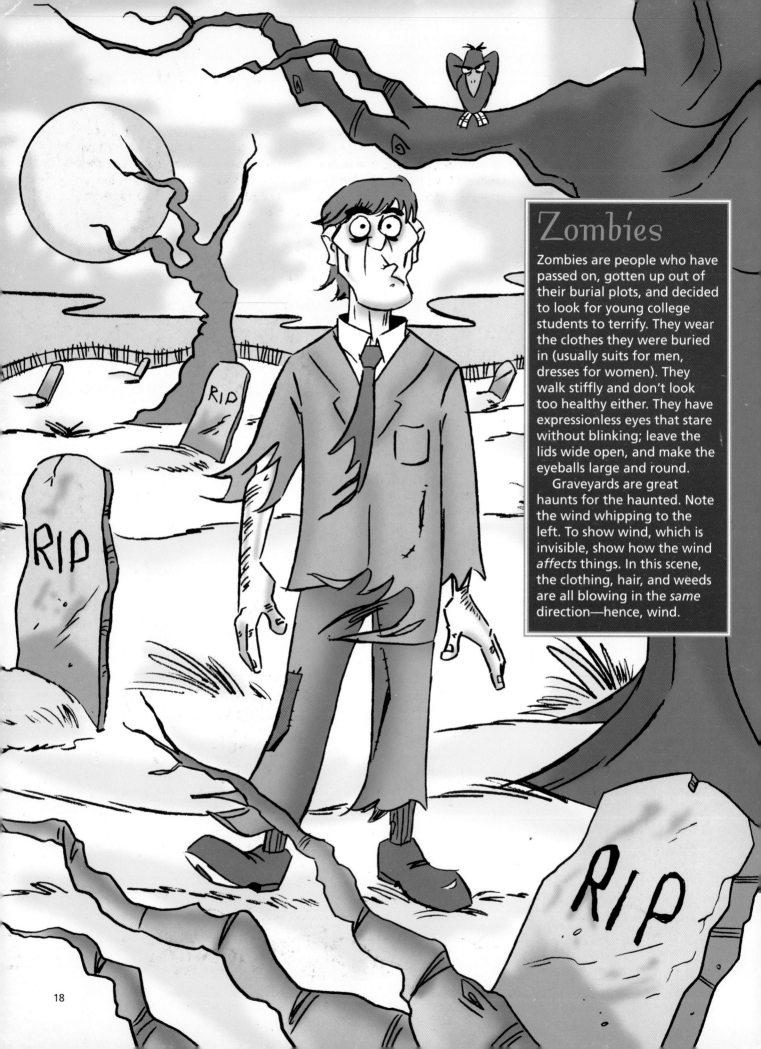

Zombies

Zombies are people who have passed on, gotten up out of their burial plots, and decided to look for young college students to terrify. They wear the clothes they were buried in (usually suits for men, dresses for women). They walk stiffly and don't look too healthy either. They have expressionless eyes that stare without blinking; leave the lids wide open, and make the eyeballs large and round.

Graveyards are great haunts for the haunted. Note the wind whipping to the left. To show wind, which is invisible, show how the wind *affects* things. In this scene, the clothing, hair, and weeds are all blowing in the *same* direction—hence, wind.

Big Monsters

The trick with these types of characters is to make them look awesome. Sure, you can create a scary face, but will that alone do the trick? Nuh-uh. You've got to make the entire physique impressive in stature. Use these tricks: Make the head slightly small for the body, and position it low on the shoulders, eliminating the neck; broaden the shoulders and narrow the waist; and draw large hands, as big as bear paws.

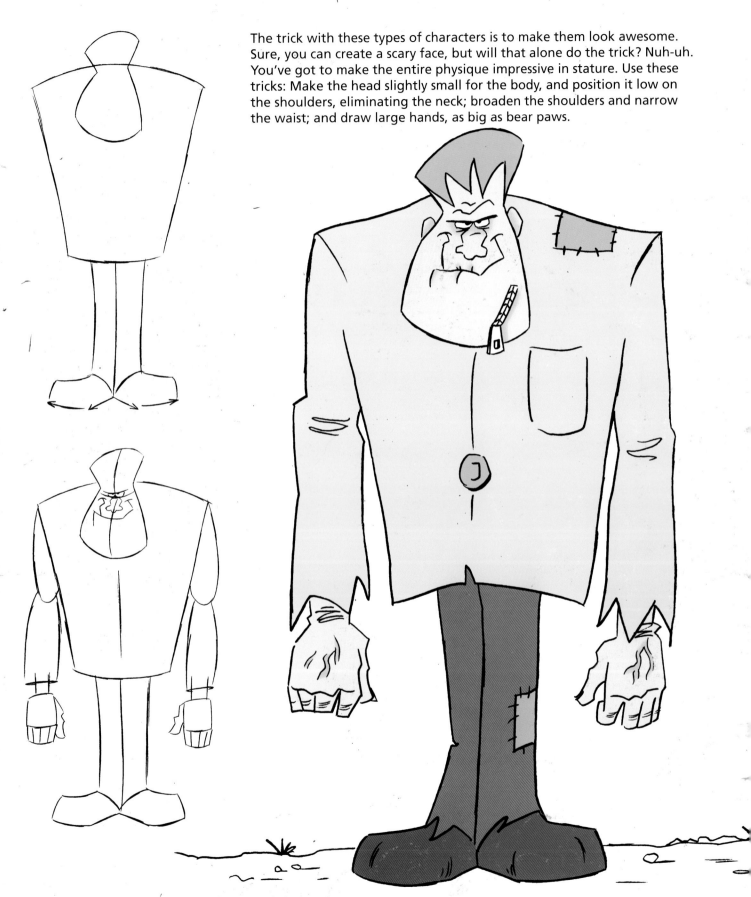

I Want My Mummy!

Mummies can be depicted many different ways. Some artists like to draw them with dusty, withered faces, but I think they make much more appealing cartoon characters if their bandages cover them from head to toe, with only their eyes peering out.

Notice how much character you can convey just from the *shapes* of the body and head alone. These three mummies each look like different characters solely because of the various shapes of their heads and bodies.

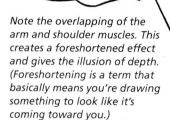

Note the overlapping of the arm and shoulder muscles. This creates a foreshortened effect and gives the illusion of depth. (Foreshortening is a term that basically means you're drawing something to look like it's coming toward you.)

MENACING
Note how large the hand is. This is due to the principles of perspective—things that are closer to us appear larger than things that are farther away.

The edge of the bandage doubles as the eyebrows.

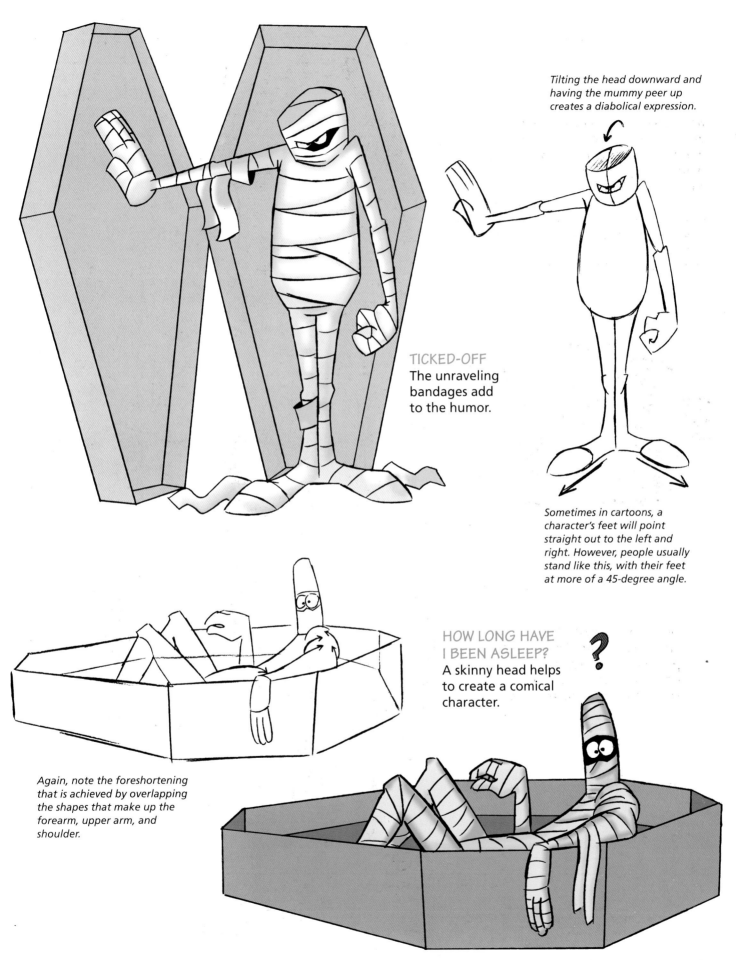

Tilting the head downward and having the mummy peer up creates a diabolical expression.

TICKED-OFF
The unraveling bandages add to the humor.

Sometimes in cartoons, a character's feet will point straight out to the left and right. However, people usually stand like this, with their feet at more of a 45-degree angle.

HOW LONG HAVE I BEEN ASLEEP?
A skinny head helps to create a comical character.

Again, note the foreshortening that is achieved by overlapping the shapes that make up the forearm, upper arm, and shoulder.

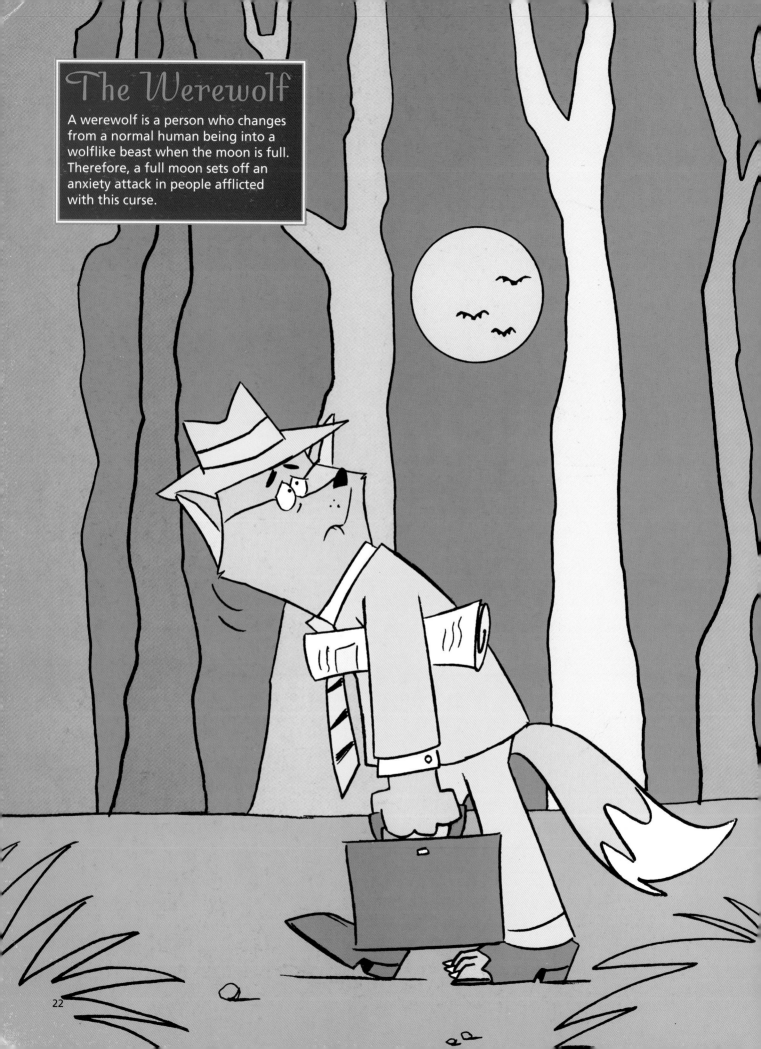

The Werewolf

A werewolf is a person who changes from a normal human being into a wolflike beast when the moon is full. Therefore, a full moon sets off an anxiety attack in people afflicted with this curse.

The Hunchback

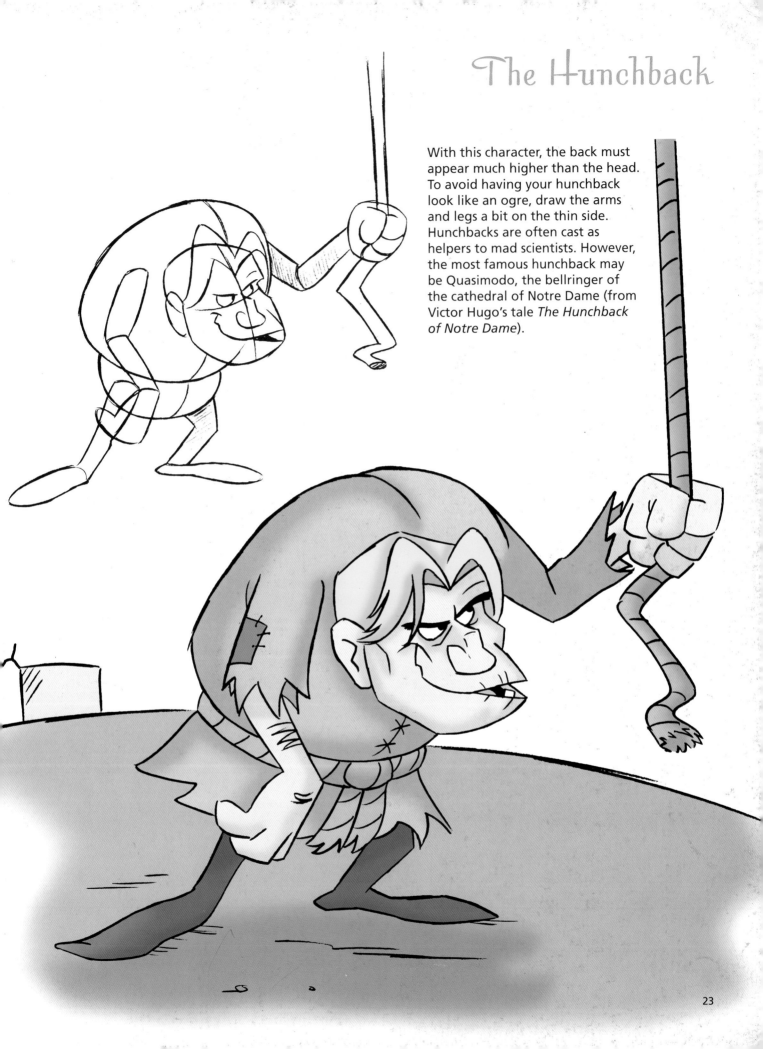

With this character, the back must appear much higher than the head. To avoid having your hunchback look like an ogre, draw the arms and legs a bit on the thin side. Hunchbacks are often cast as helpers to mad scientists. However, the most famous hunchback may be Quasimodo, the bellringer of the cathedral of Notre Dame (from Victor Hugo's tale *The Hunchback of Notre Dame*).

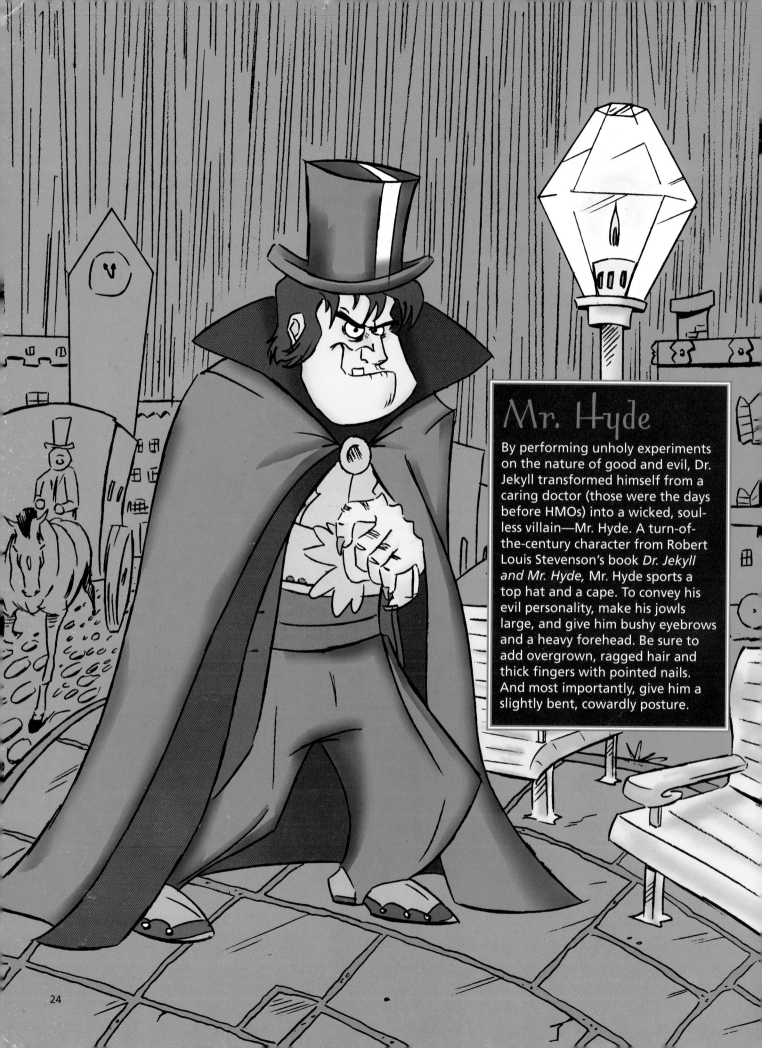

Mr. Hyde

By performing unholy experiments on the nature of good and evil, Dr. Jekyll transformed himself from a caring doctor (those were the days before HMOs) into a wicked, soulless villain—Mr. Hyde. A turn-of-the-century character from Robert Louis Stevenson's book *Dr. Jekyll and Mr. Hyde,* Mr. Hyde sports a top hat and a cape. To convey his evil personality, make his jowls large, and give him bushy eyebrows and a heavy forehead. Be sure to add overgrown, ragged hair and thick fingers with pointed nails. And most importantly, give him a slightly bent, cowardly posture.

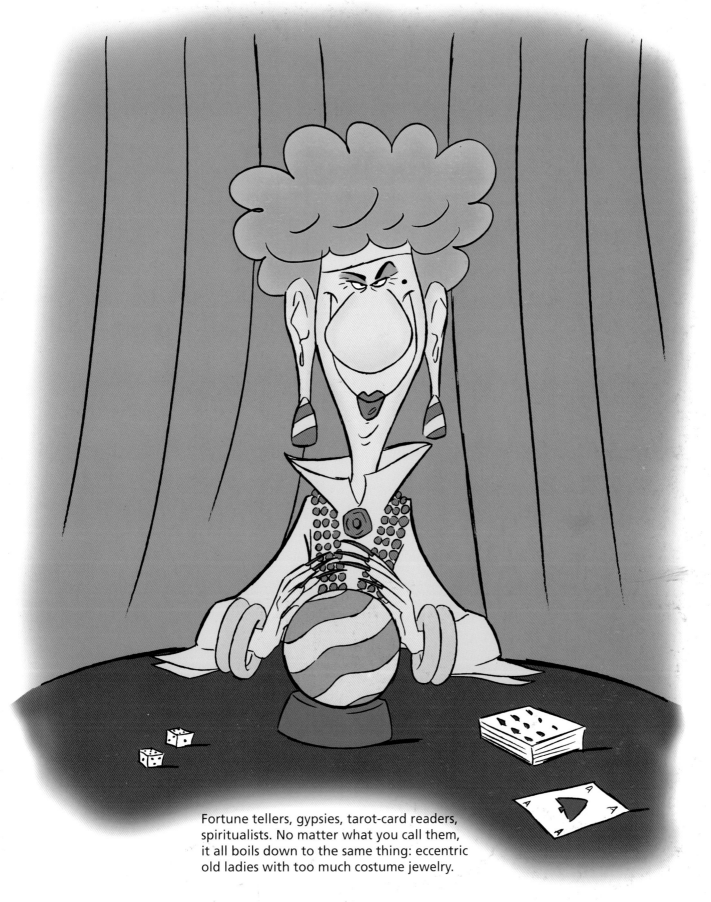

Fortune tellers, gypsies, tarot-card readers, spiritualists. No matter what you call them, it all boils down to the same thing: eccentric old ladies with too much costume jewelry.

Headless Guys

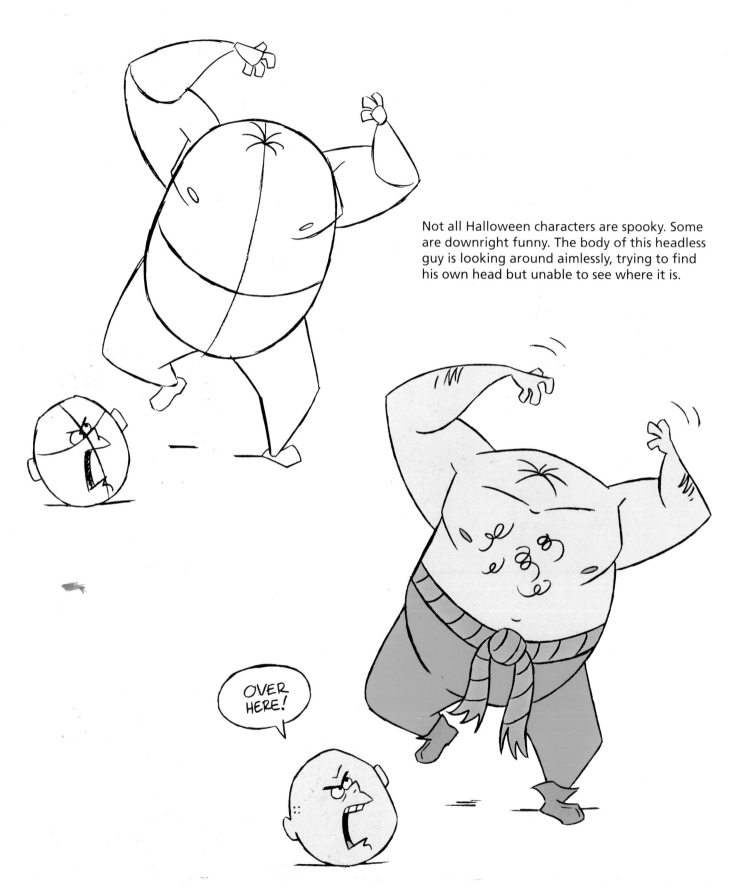

Not all Halloween characters are spooky. Some are downright funny. The body of this headless guy is looking around aimlessly, trying to find his own head but unable to see where it is.

OVER HERE!

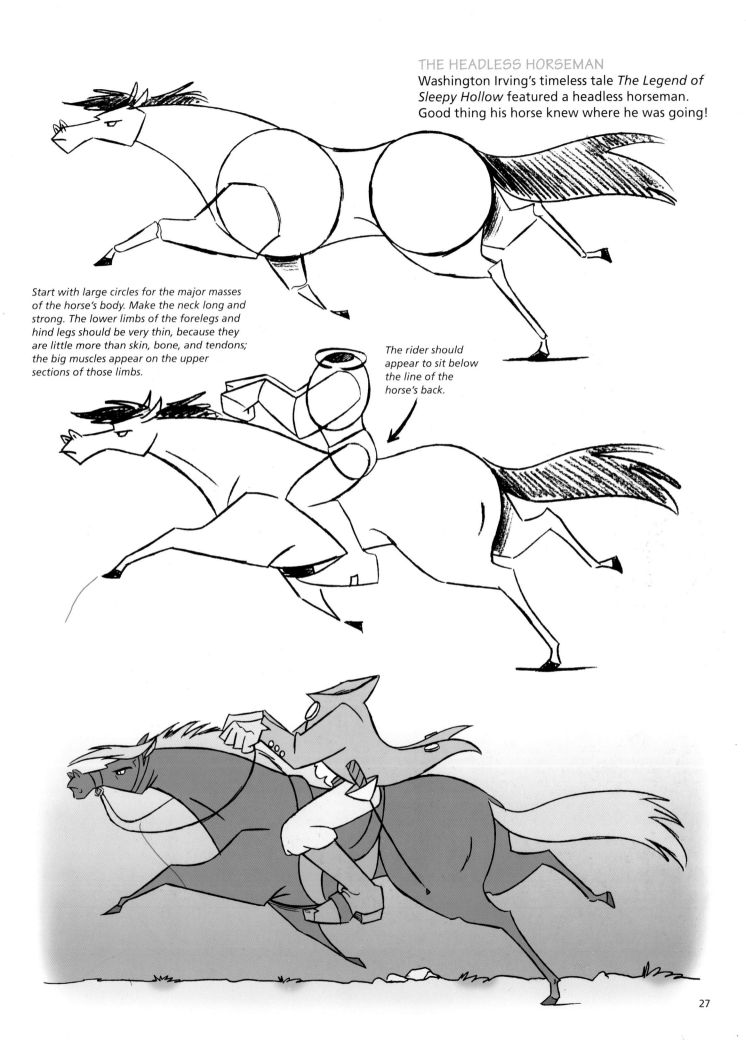

Washington Irving's timeless tale *The Legend of Sleepy Hollow* featured a headless horseman. Good thing his horse knew where he was going!

Start with large circles for the major masses of the horse's body. Make the neck long and strong. The lower limbs of the forelegs and hind legs should be very thin, because they are little more than skin, bone, and tendons; the big muscles appear on the upper sections of those limbs.

The rider should appear to sit below the line of the horse's back.

27

Batty Bats

Bats and Halloween belong together. Most people draw simple silhouettes of bats, like the Batman symbol. That's okay as far as it goes, but it's more fun to get inventive with these animals and create your own batty characters.

Bat wings are made of thin skin, which attaches to bony arms that extend into hands. Also, bats have long tails, fangs, and pointed ears.

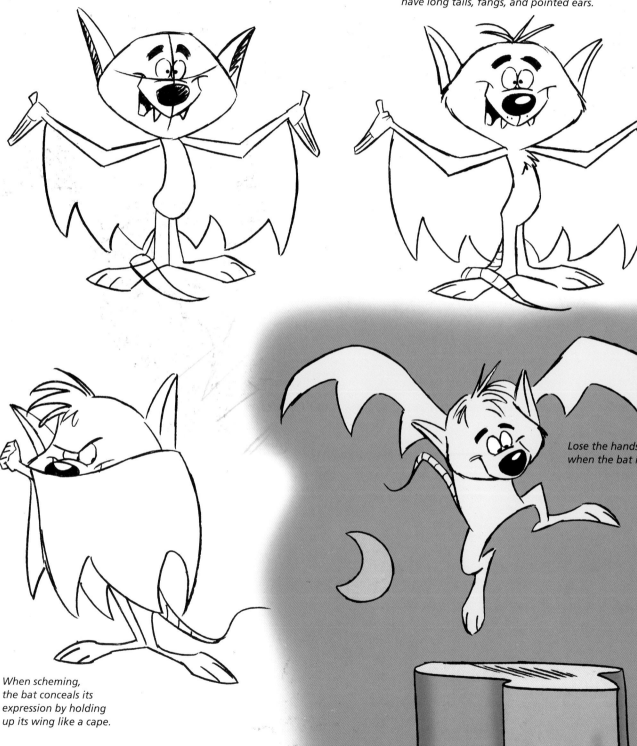

When scheming, the bat conceals its expression by holding up its wing like a cape.

Lose the hands when the bat is flying.

Goblins and Gremlins

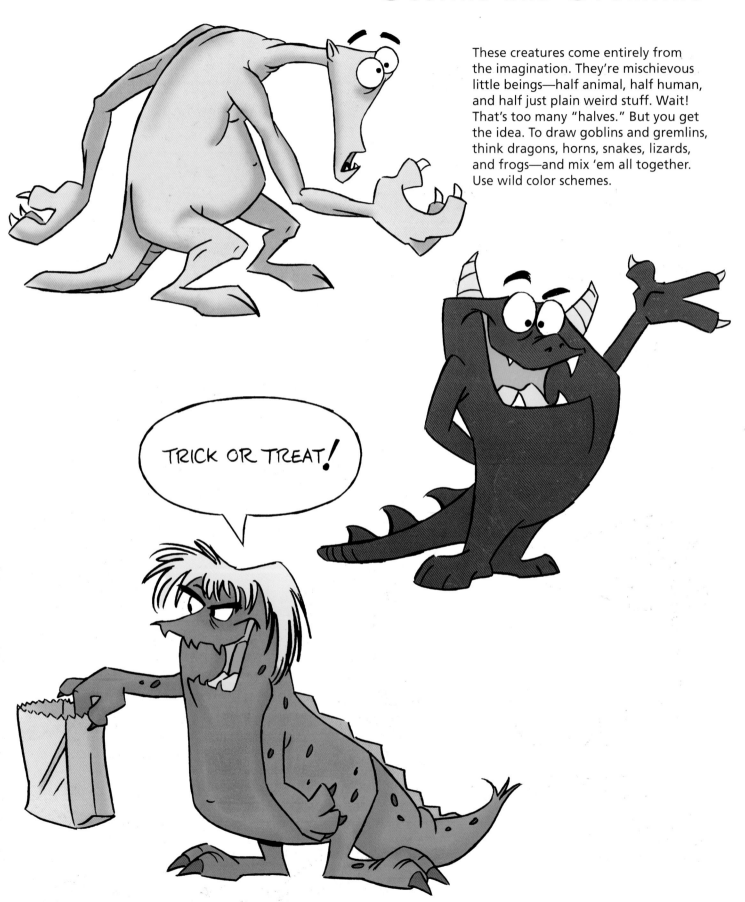

These creatures come entirely from the imagination. They're mischievous little beings—half animal, half human, and half just plain weird stuff. Wait! That's too many "halves." But you get the idea. To draw goblins and gremlins, think dragons, horns, snakes, lizards, and frogs—and mix 'em all together. Use wild color schemes.

TRICK OR TREAT!

Ninjas

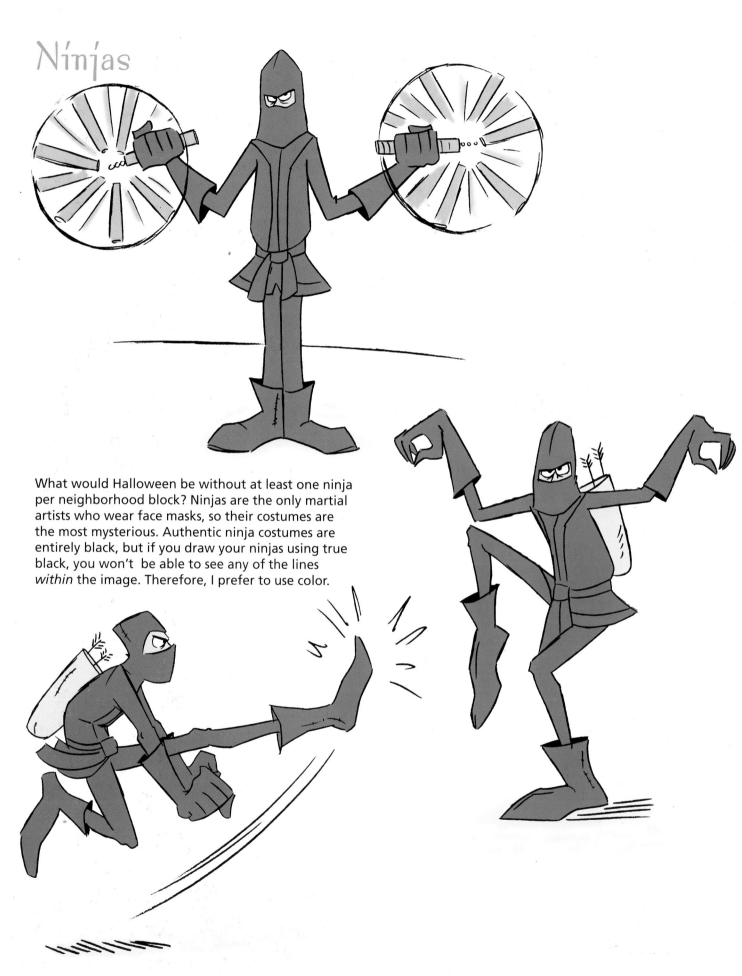

What would Halloween be without at least one ninja per neighborhood block? Ninjas are the only martial artists who wear face masks, so their costumes are the most mysterious. Authentic ninja costumes are entirely black, but if you draw your ninjas using true black, you won't be able to see any of the lines *within* the image. Therefore, I prefer to use color.

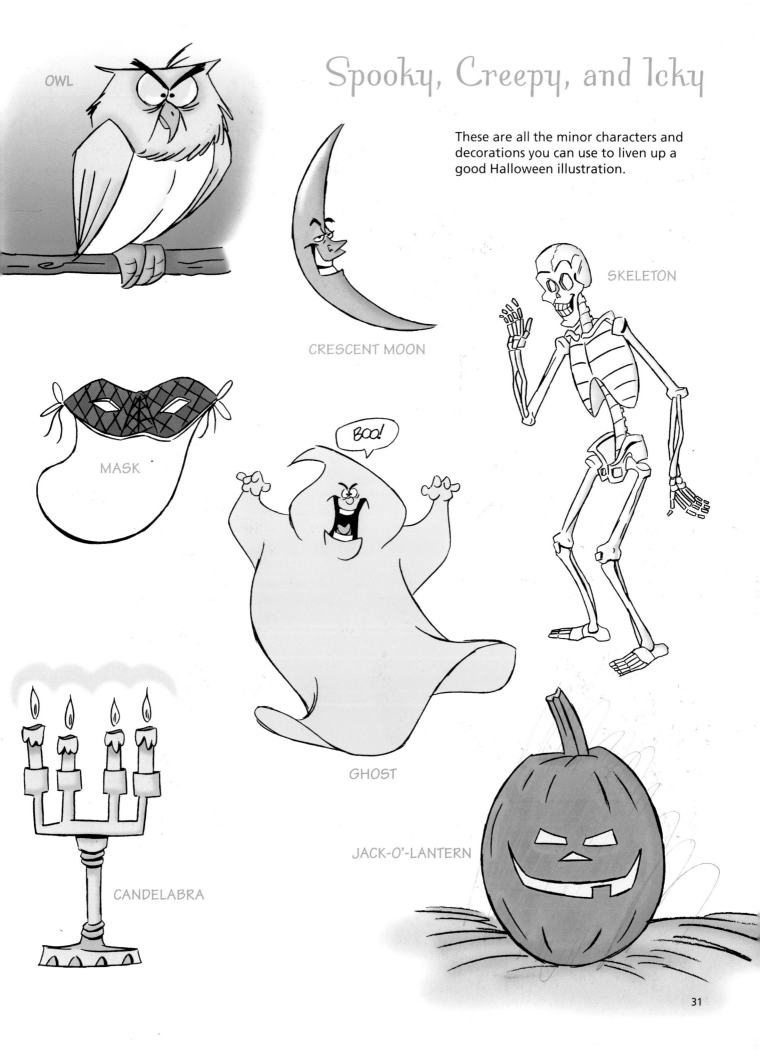

OWL

Spooky, Creepy, and Icky

These are all the minor characters and decorations you can use to liven up a good Halloween illustration.

CRESCENT MOON

SKELETON

MASK

BOO!

GHOST

JACK-O'-LANTERN

CANDELABRA

The Classic Haunted House

Nothing casts an eerie glow over a story like an opening shot of a haunted house. Haunted houses are typically two-story Victorian homes with gingerbread-style rooftops. They need to be in utter disrepair and, preferably, located right next to a cemetery. (Location, location, location!)

Typically, there's a rusted and gnarled wrought-iron fence at the foreboding entrance. The stairs leading up to the double wooden doors are missing slats. And the spaces between the latticework under the porch are dark. A weather vain crowns the house, and the whole scene is punctuated by a full moon. At least one leafless, twisted tree should be close by, and you shouldn't be able to see anything through the darkened windows except for drapery—or perhaps shadows.

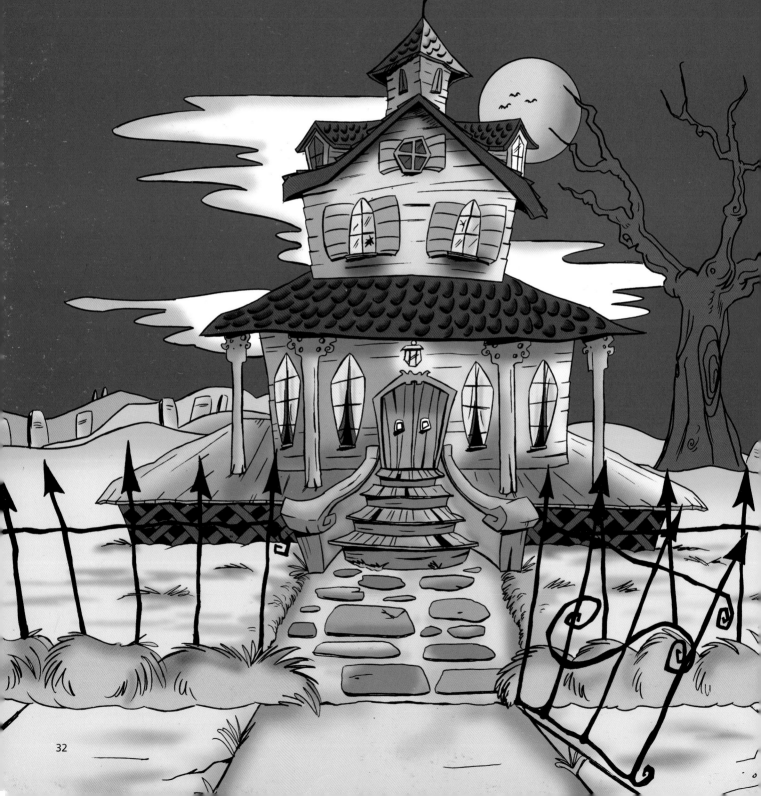

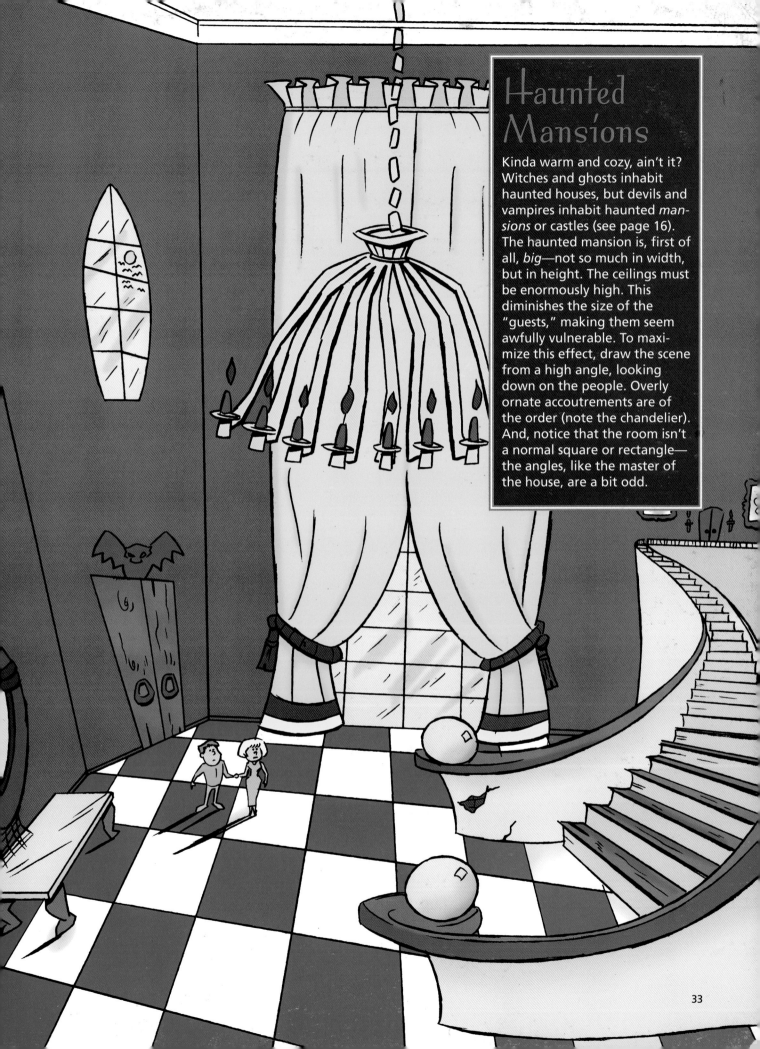

Haunted Mansions

Kinda warm and cozy, ain't it? Witches and ghosts inhabit haunted houses, but devils and vampires inhabit haunted *mansions* or castles (see page 16). The haunted mansion is, first of all, *big*—not so much in width, but in height. The ceilings must be enormously high. This diminishes the size of the "guests," making them seem awfully vulnerable. To maximize this effect, draw the scene from a high angle, looking down on the people. Overly ornate accoutrements are of the order (note the chandelier). And, notice that the room isn't a normal square or rectangle— the angles, like the master of the house, are a bit odd.

CHRISTMAS CHARACTERS

Christmas is the grand daddy of classic American holidays. It's hard to capture in pictures the magic that lives in a child's heart the night before Christmas, but there are several important ideas that can bring you close. Remember to strive for charm, good humor, warmth, and wonder.

Santa Claus

Santa Claus went through several transformations before becoming the big, jolly guy we know today. Originally, he was pictured as a tiny elf, which is why he was said to be able to fit in a chimney flue. Today, Santa retains all his former elfin magic, but with a huge size to match his personality. Since he's always shown with a beard, you should incorporate the shape of the beard into the basic structure of his face. Notice that the mouth is drawn completely first—then the mustache is drawn over it.

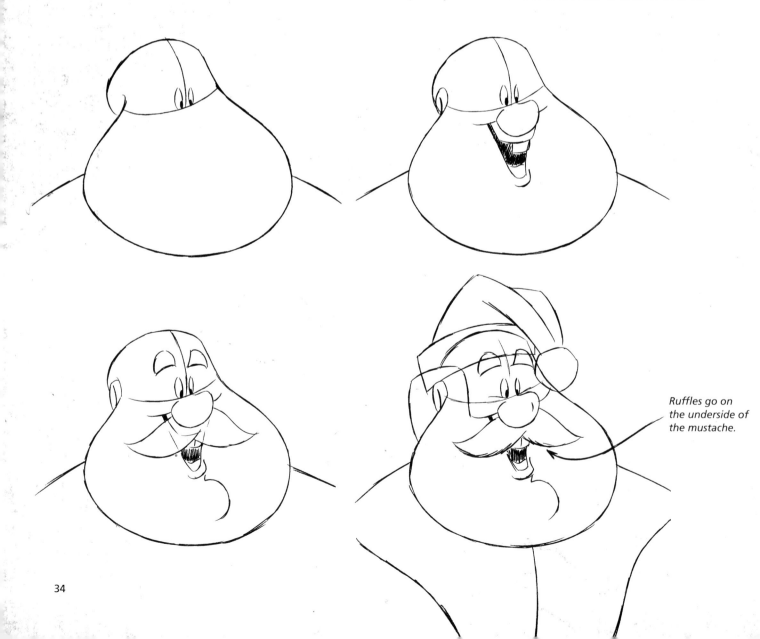

Ruffles go on the underside of the mustache.

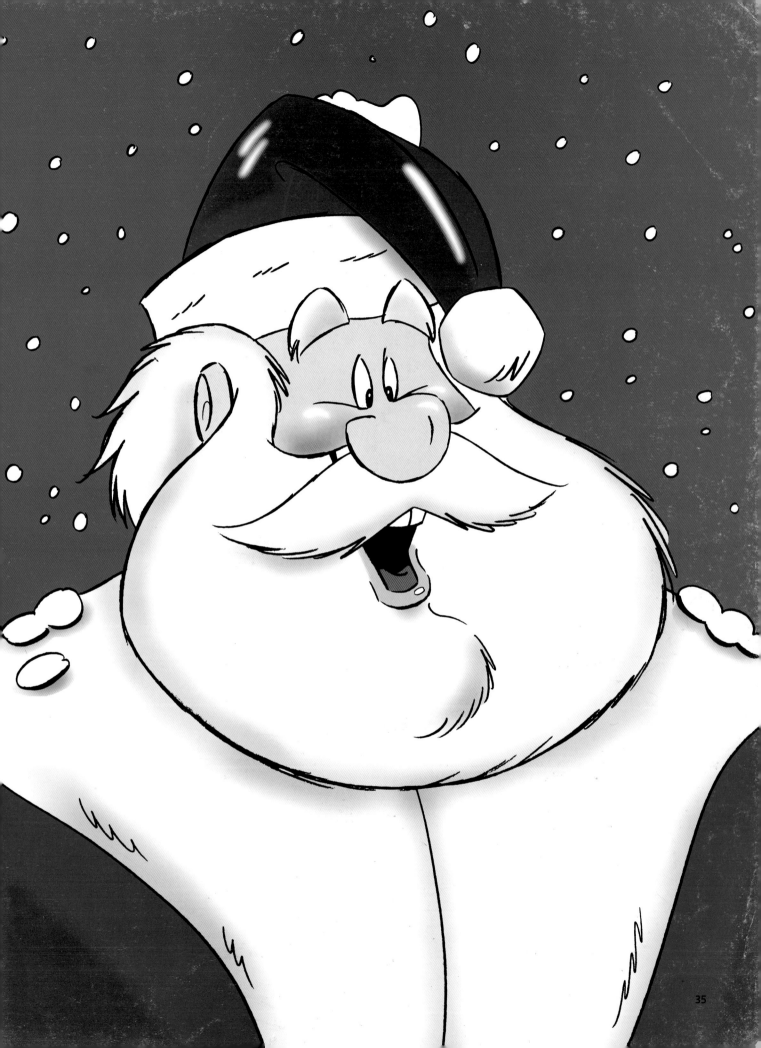

Santa's Body

Santa's body is rotund but not obese. Due to perspective, the center of his belt should look larger than the sides of it, because it is closer to you at the center. This makes his tummy look rounder. Note: Some Santas wear bifocals—assembling all those music boxes can be hard on the eyes.

Belt is largest here

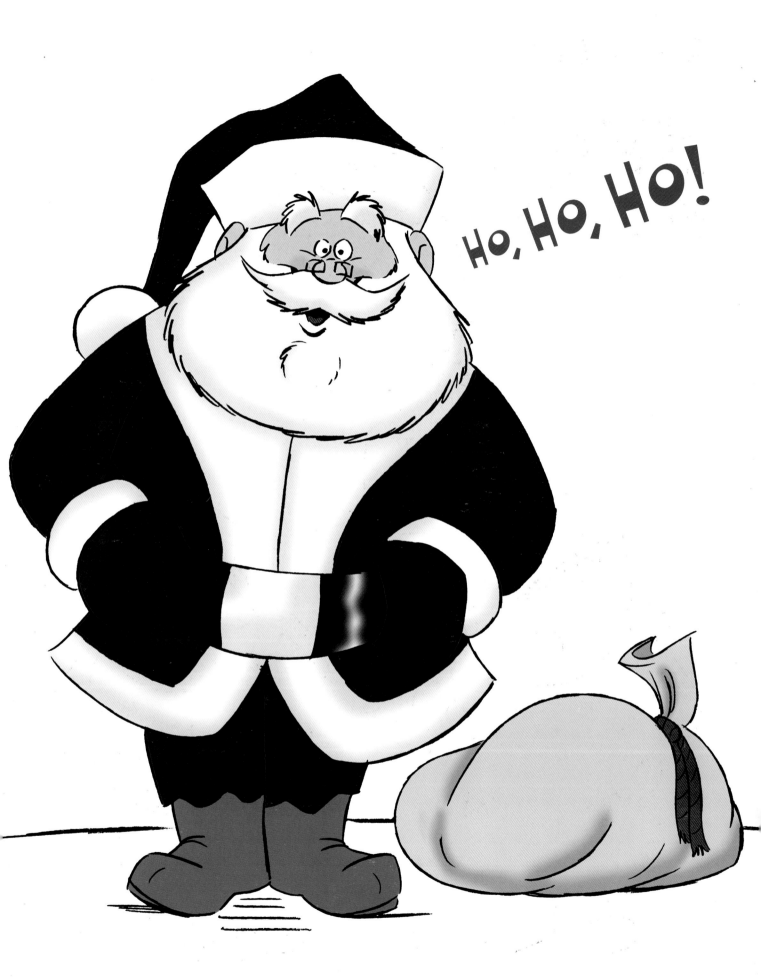

Elves: Santa's Helpers

For some reason, these guys never formed a union. And it's a good thing. The first demand they'd probably make is to get Christmas off. The thing to remember about elves is that although they're tiny, their limbs should be long and thin. Give them pointed noses and ears, and slightly kooky or mischievous expressions. A proper outfit, like the one here, will complete the character.

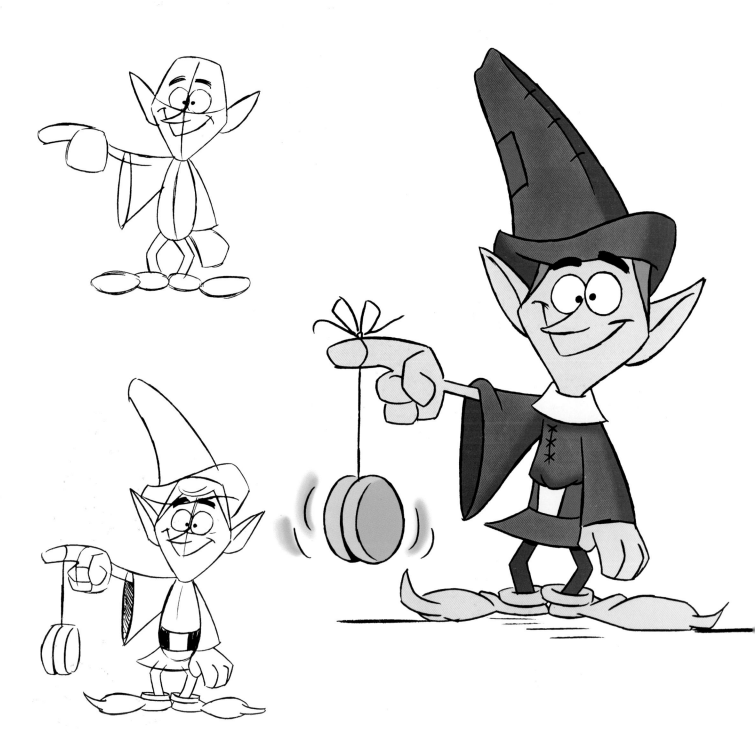

Edgy Elf

Since they're slightly goofy to begin with, elves can easily be drawn in an edgy style. Edgy characters exhibit a strange, weird quality. Adding a slightly bizarre element to your drawings makes them more cutting edge.

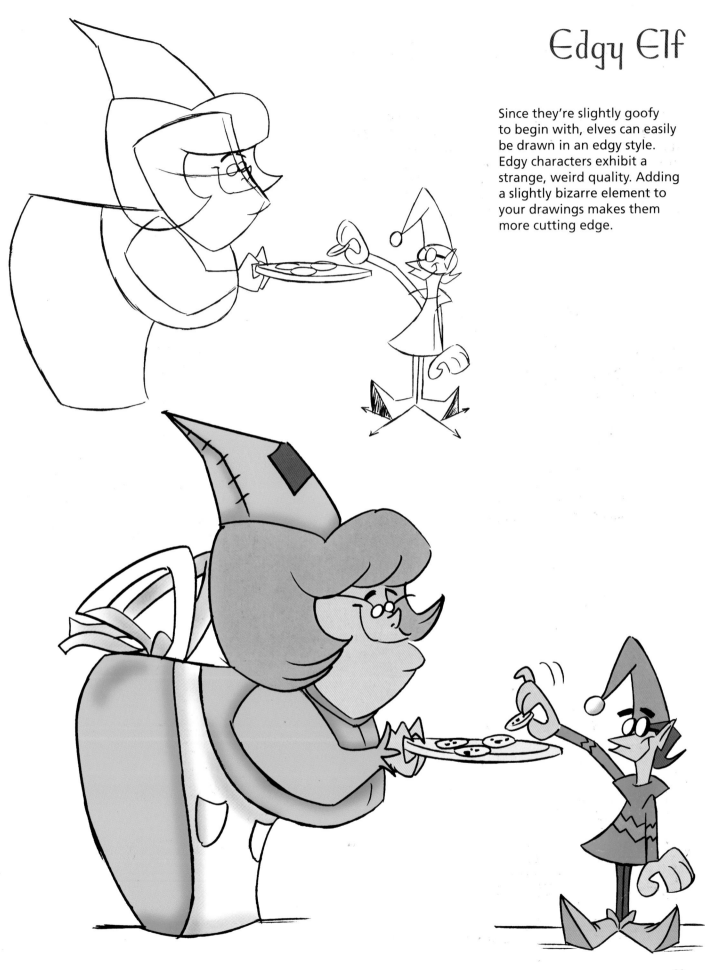

Reindeer

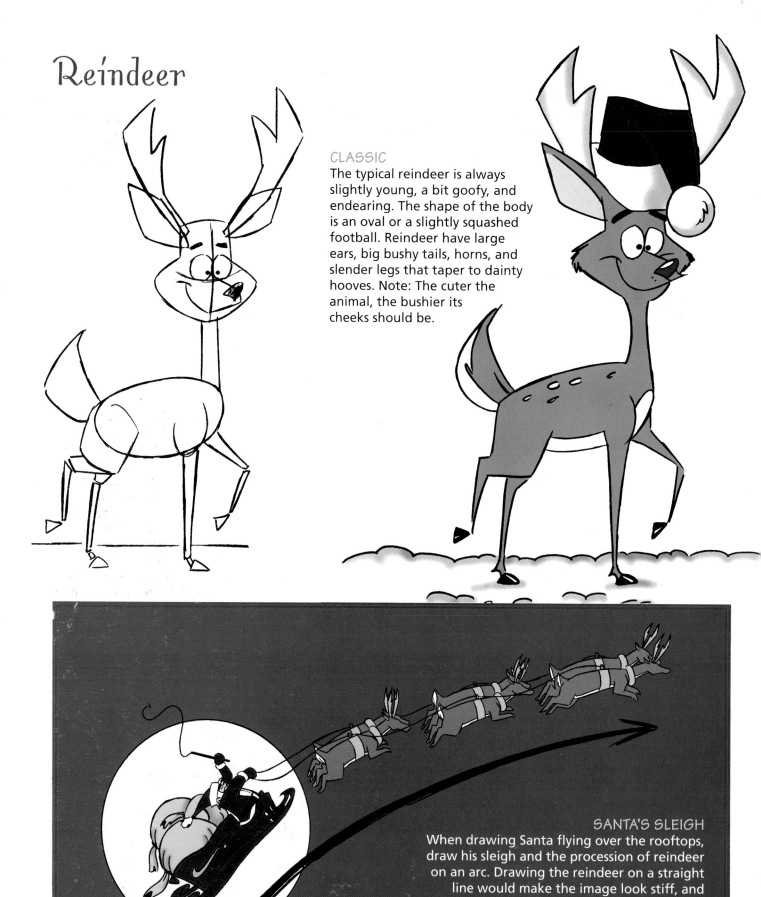

CLASSIC
The typical reindeer is always slightly young, a bit goofy, and endearing. The shape of the body is an oval or a slightly squashed football. Reindeer have large ears, big bushy tails, horns, and slender legs that taper to dainty hooves. Note: The cuter the animal, the bushier its cheeks should be.

SANTA'S SLEIGH
When drawing Santa flying over the rooftops, draw his sleigh and the procession of reindeer on an arc. Drawing the reindeer on a straight line would make the image look stiff, and curved lines are inherently more pleasing to the eye than straight ones. Note that Santa looks good framed within a large full moon.

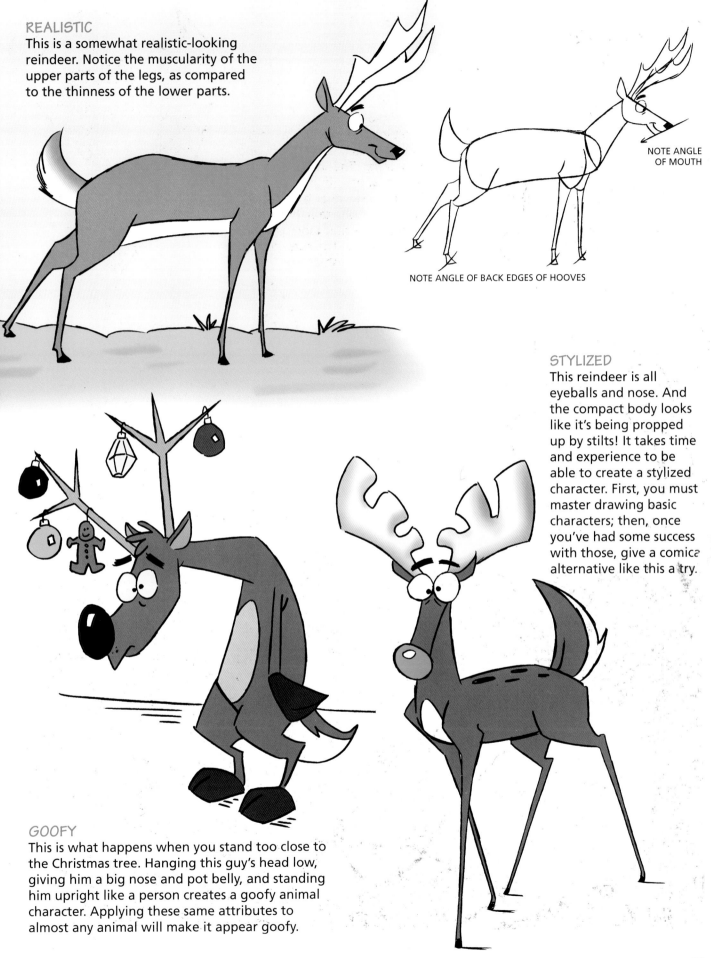

REALISTIC
This is a somewhat realistic-looking reindeer. Notice the muscularity of the upper parts of the legs, as compared to the thinness of the lower parts.

NOTE ANGLE OF MOUTH

NOTE ANGLE OF BACK EDGES OF HOOVES

STYLIZED
This reindeer is all eyeballs and nose. And the compact body looks like it's being propped up by stilts! It takes time and experience to be able to create a stylized character. First, you must master drawing basic characters; then, once you've had some success with those, give a comical alternative like this a try.

GOOFY
This is what happens when you stand too close to the Christmas tree. Hanging this guy's head low, giving him a big nose and pot belly, and standing him upright like a person creates a goofy animal character. Applying these same attributes to almost any animal will make it appear goofy.

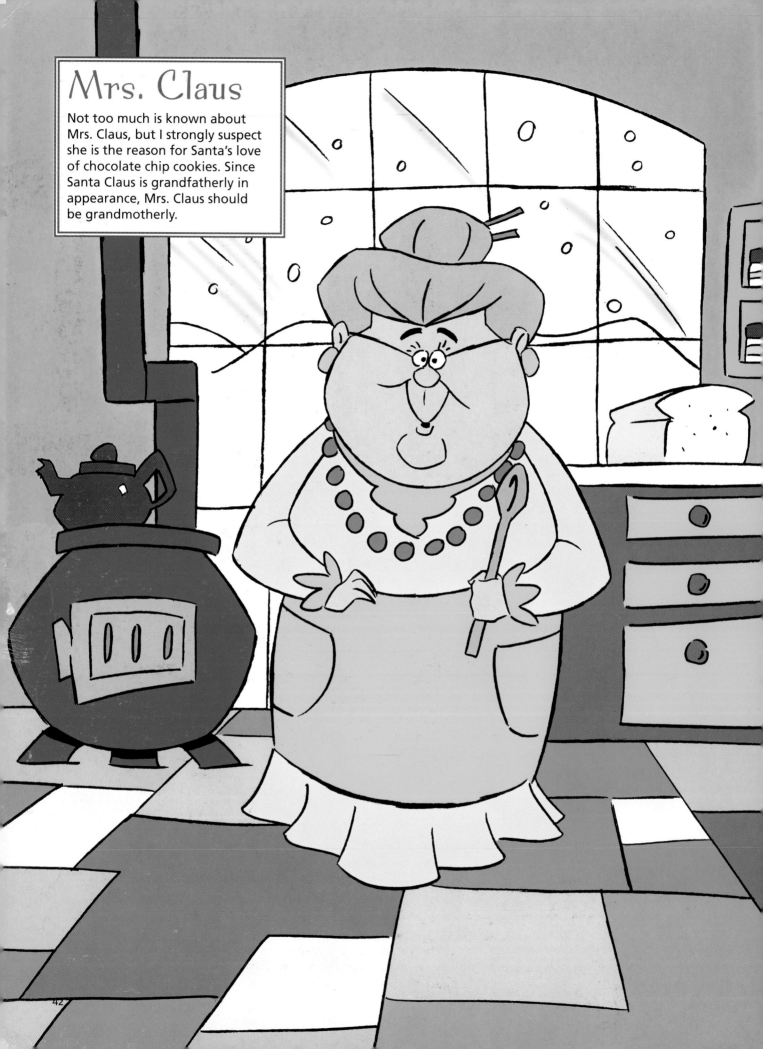

Mrs. Claus

Not too much is known about Mrs. Claus, but I strongly suspect she is the reason for Santa's love of chocolate chip cookies. Since Santa Claus is grandfatherly in appearance, Mrs. Claus should be grandmotherly.

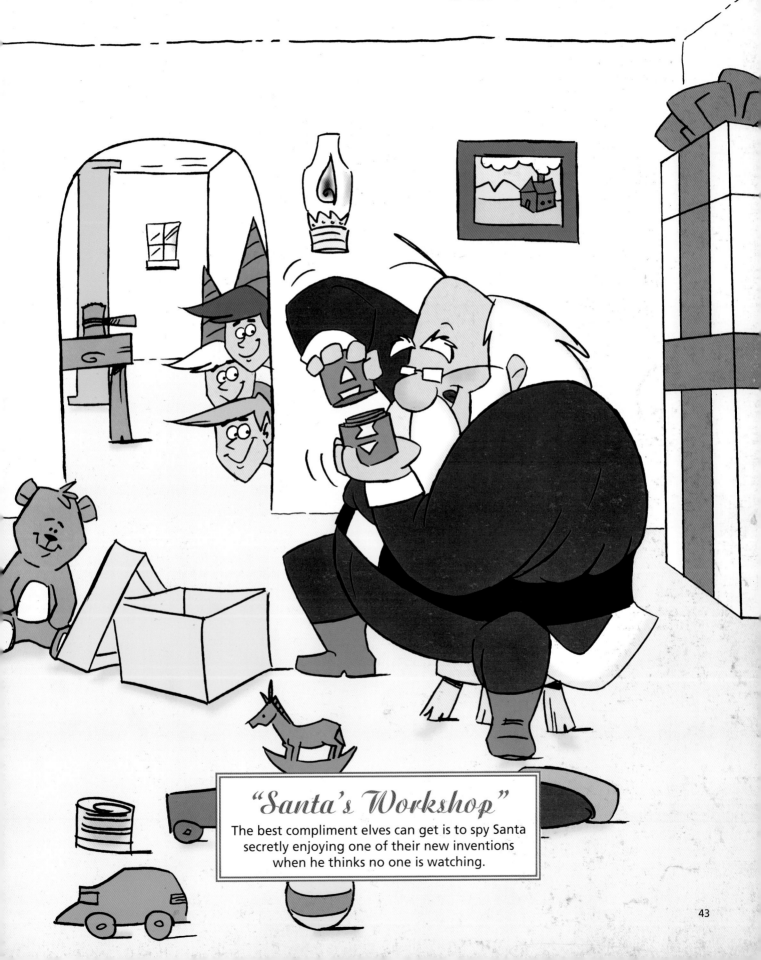

"Santa's Workshop"

The best compliment elves can get is to spy Santa secretly enjoying one of their new inventions when he thinks no one is watching.

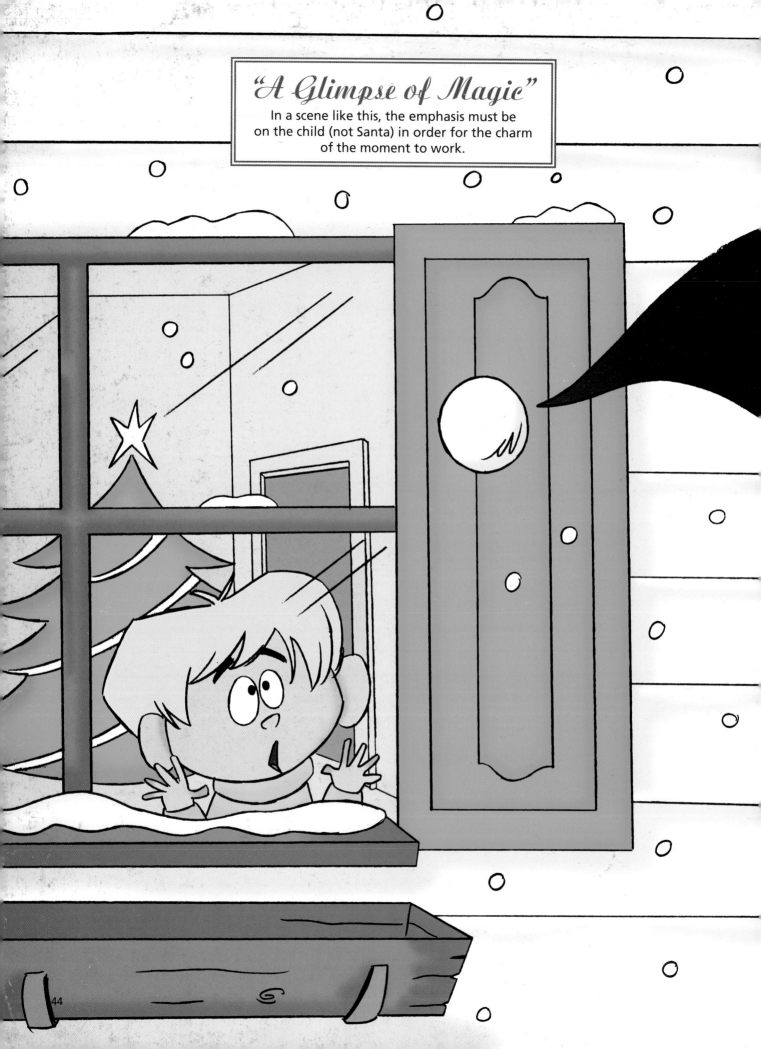

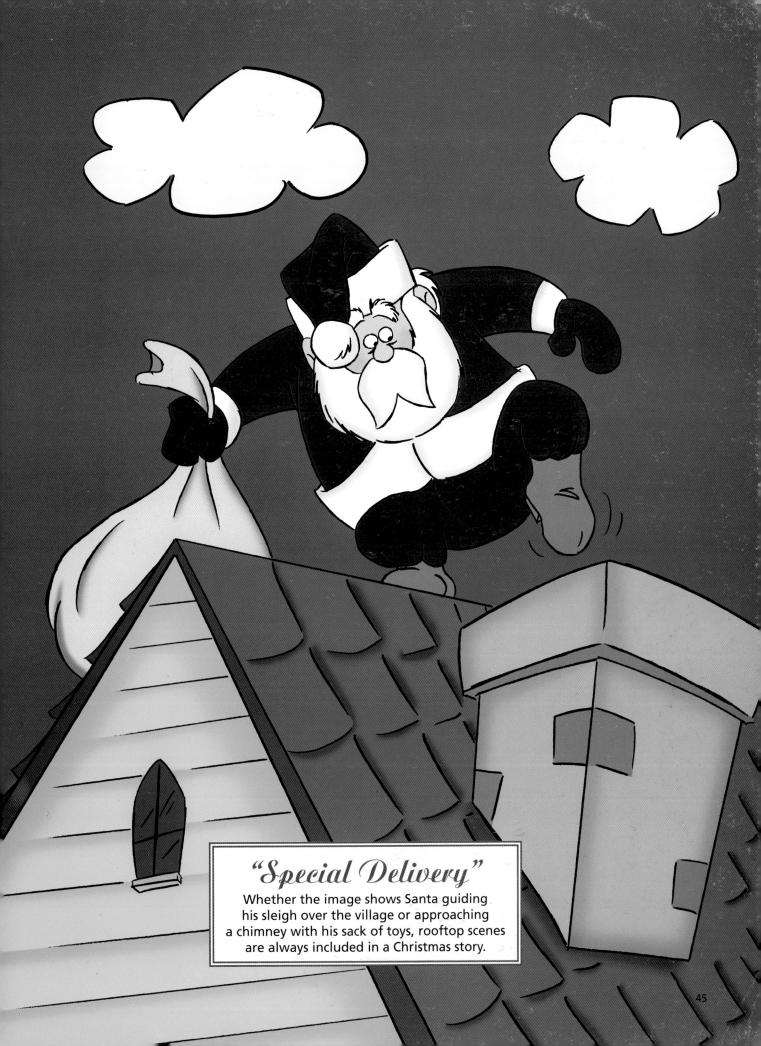

"Special Delivery"

Whether the image shows Santa guiding
his sleigh over the village or approaching
a chimney with his sack of toys, rooftop scenes
are always included in a Christmas story.

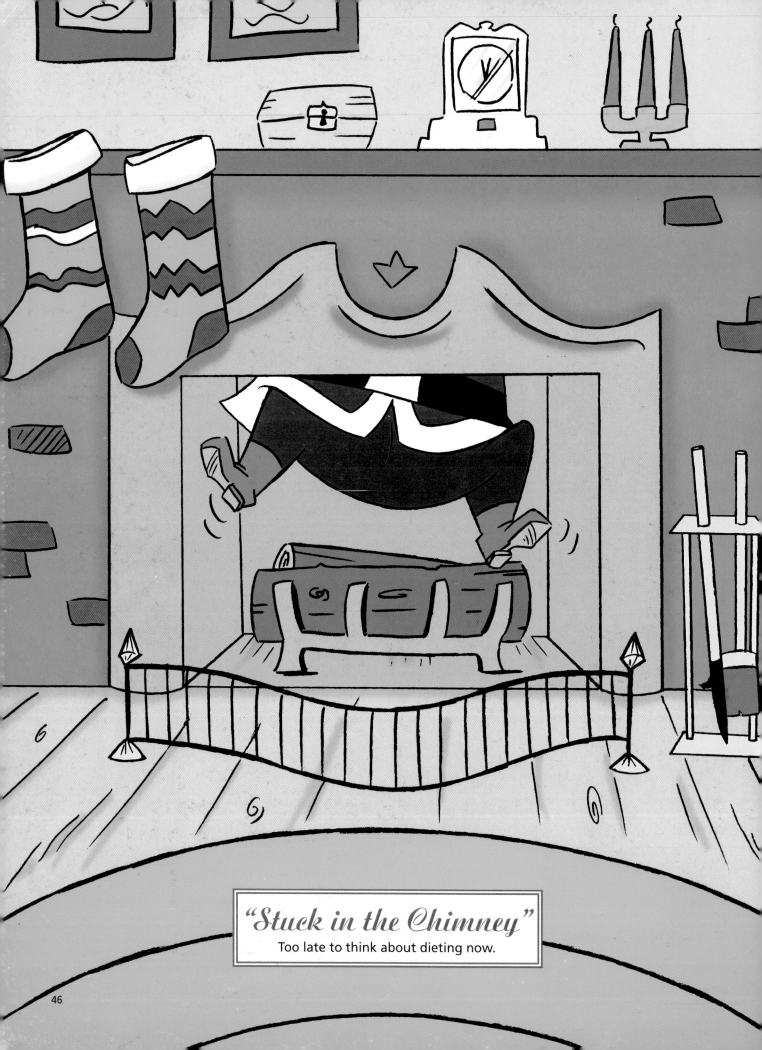

"*Stuck in the Chimney*"
Too late to think about dieting now.

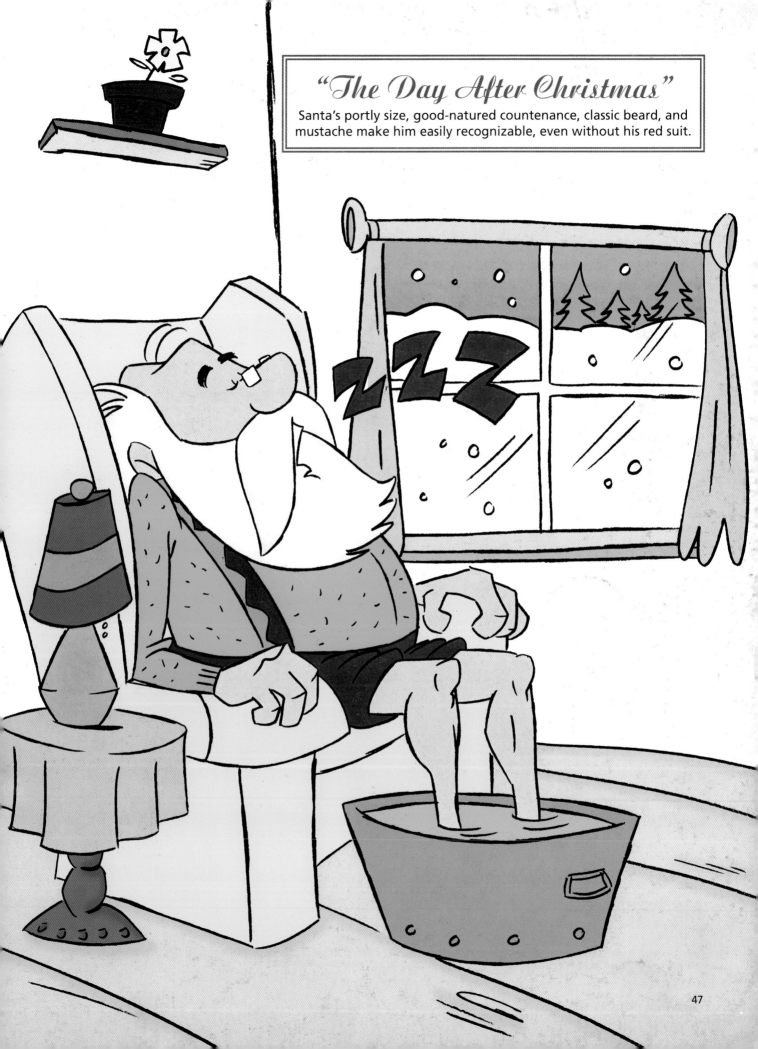

"The Day After Christmas"

Santa's portly size, good-natured countenance, classic beard, and mustache make him easily recognizable, even without his red suit.

A Christmas Carol

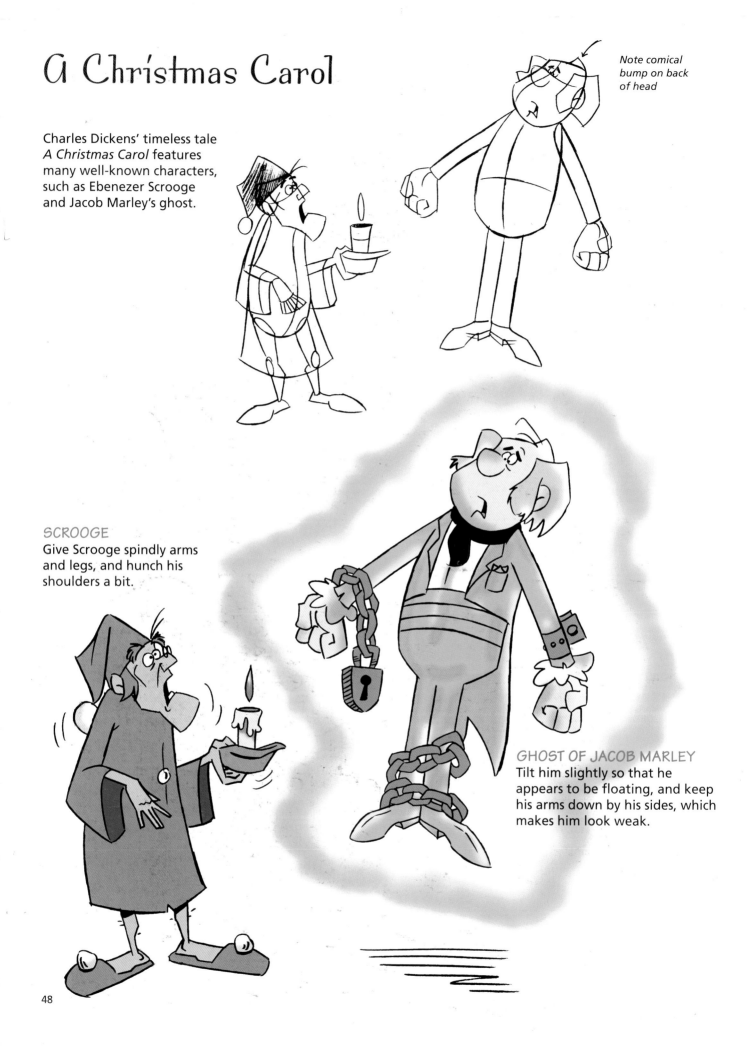

Charles Dickens' timeless tale *A Christmas Carol* features many well-known characters, such as Ebenezer Scrooge and Jacob Marley's ghost.

Note comical bump on back of head

SCROOGE
Give Scrooge spindly arms and legs, and hunch his shoulders a bit.

GHOST OF JACOB MARLEY
Tilt him slightly so that he appears to be floating, and keep his arms down by his sides, which makes him look weak.

Christmas Carolers

To depict people singing, draw them with their mouths opened wide, their heads tilted, and their eyes shut. Note, however, that this scene features four people singing, and if I positioned all four the exact same way, the scene would become monotonous. As a result, the reader would lose interest. So to avoid this, I've altered the smallest girl: I've drawn her *eyes* wide open, kept her head straight, and opened her mouth only a little bit.

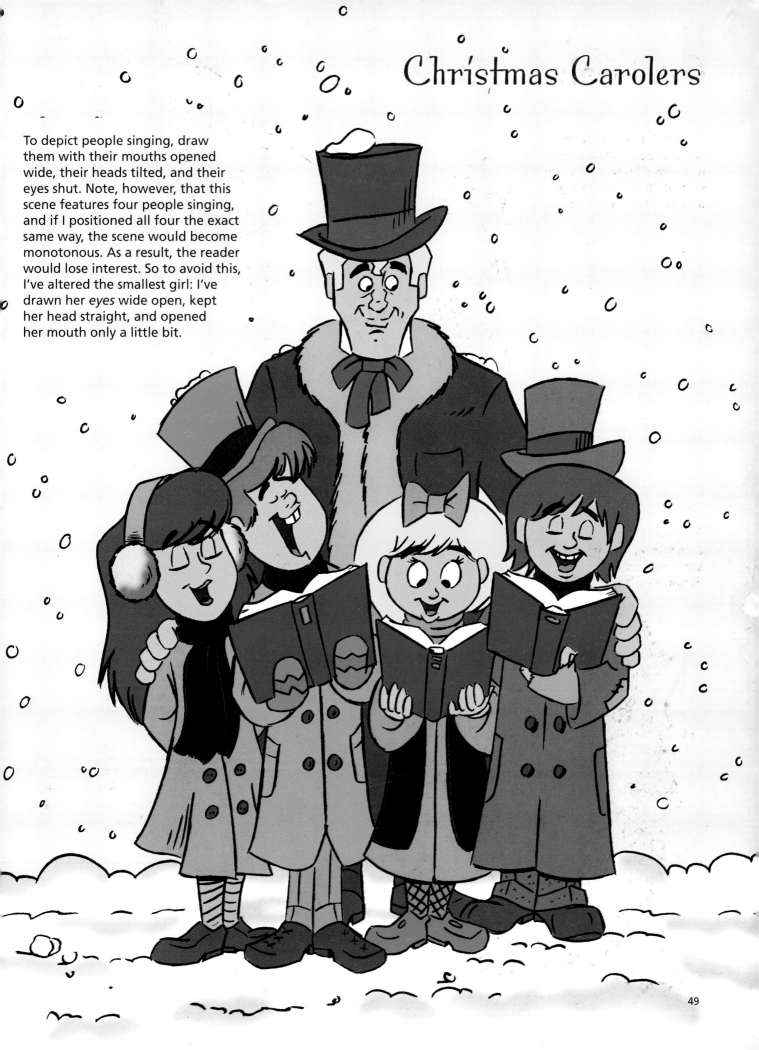

The Nutcracker

The Nutcracker is *the* Christmas ballet, performed each year during the Christmas season for children who plead with their parents to let them stay home and watch cartoons instead. (You're not alone—my parents didn't listen to me either.) In this and other Christmas tales, toy nutcrackers are really miniature soldiers. They often carry decorative swords and are dressed with lots of flair and pomp. Keep the platform under the soldier as part of your character. It's what makes him look like a toy.

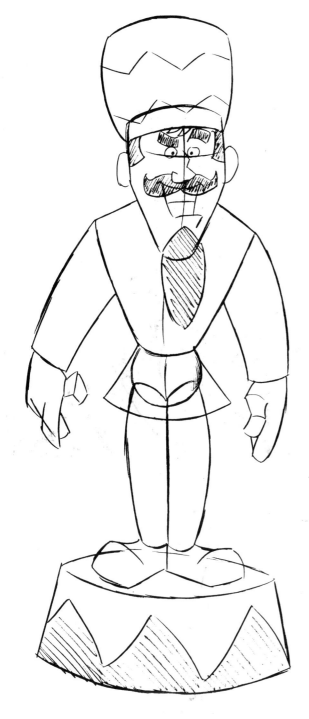

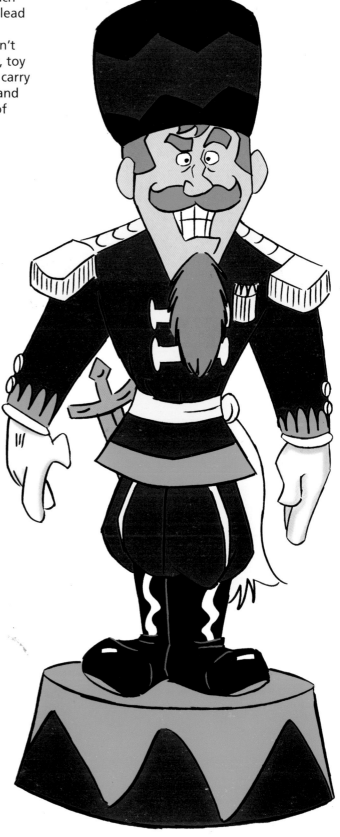

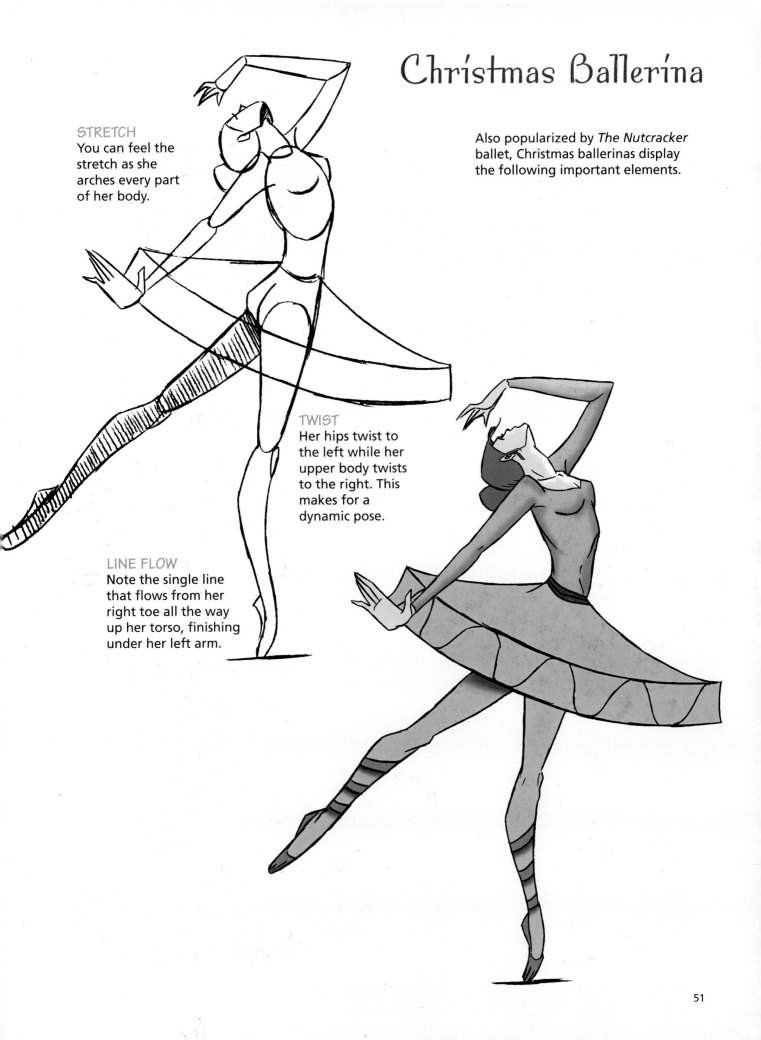

Christmas Ballerina

STRETCH
You can feel the stretch as she arches every part of her body.

Also popularized by *The Nutcracker* ballet, Christmas ballerinas display the following important elements.

TWIST
Her hips twist to the left while her upper body twists to the right. This makes for a dynamic pose.

LINE FLOW
Note the single line that flows from her right toe all the way up her torso, finishing under her left arm.

Snow Fairies

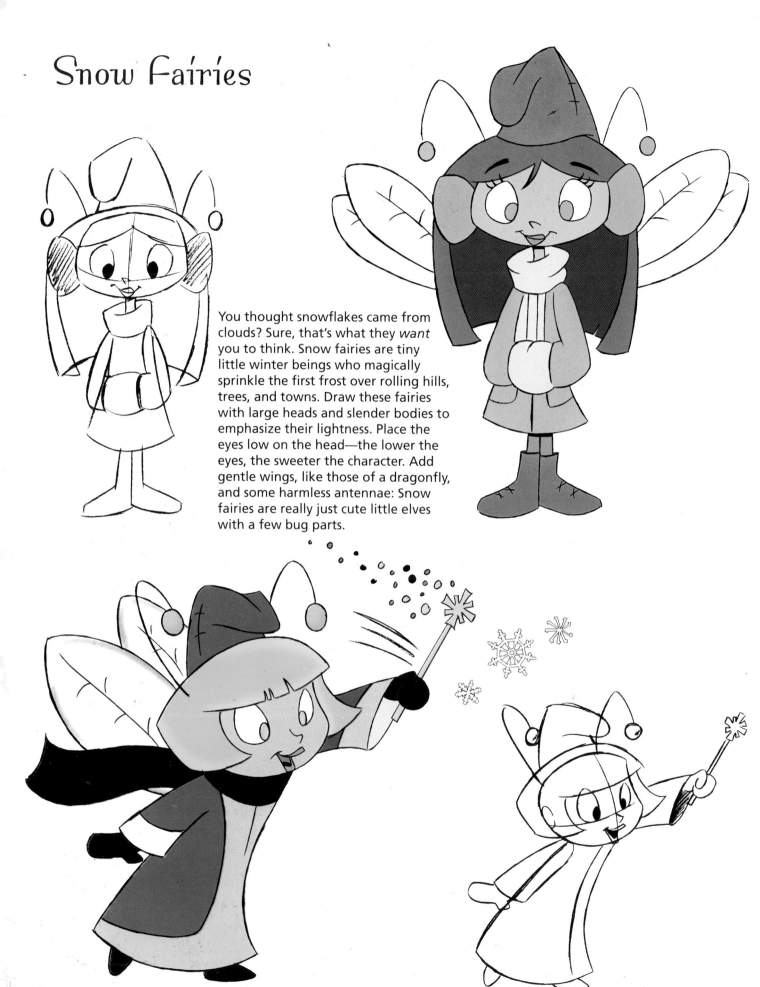

You thought snowflakes came from clouds? Sure, that's what they *want* you to think. Snow fairies are tiny little winter beings who magically sprinkle the first frost over rolling hills, trees, and towns. Draw these fairies with large heads and slender bodies to emphasize their lightness. Place the eyes low on the head—the lower the eyes, the sweeter the character. Add gentle wings, like those of a dragonfly, and some harmless antennae: Snow fairies are really just cute little elves with a few bug parts.

Different Types of Christmas Trees

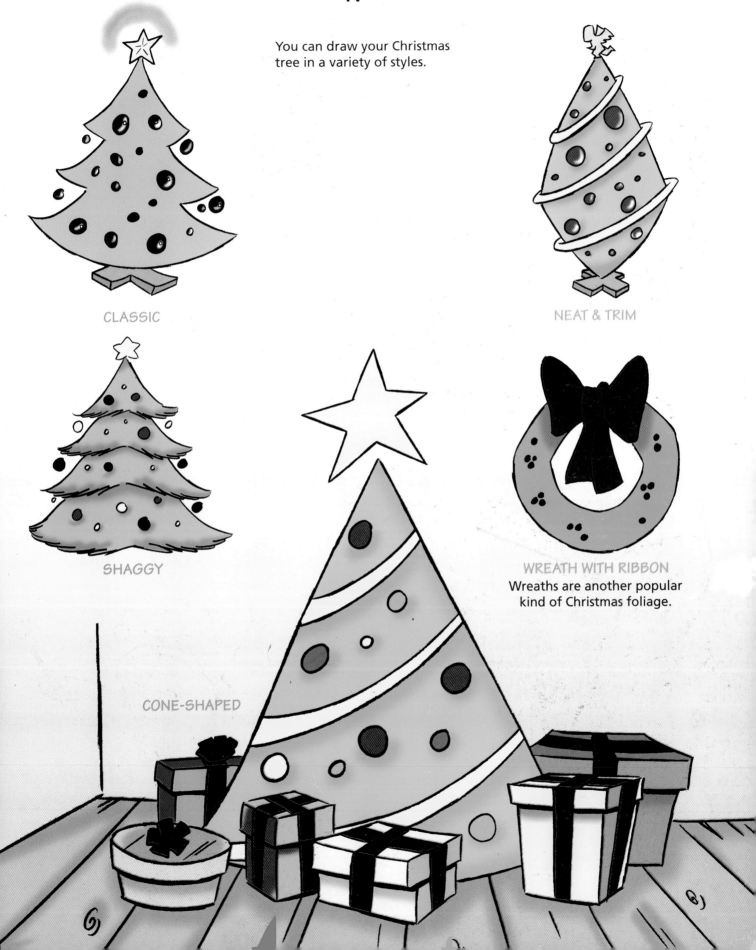

You can draw your Christmas tree in a variety of styles.

CLASSIC

NEAT & TRIM

SHAGGY

CONE-SHAPED

WREATH WITH RIBBON

Wreaths are another popular kind of Christmas foliage.

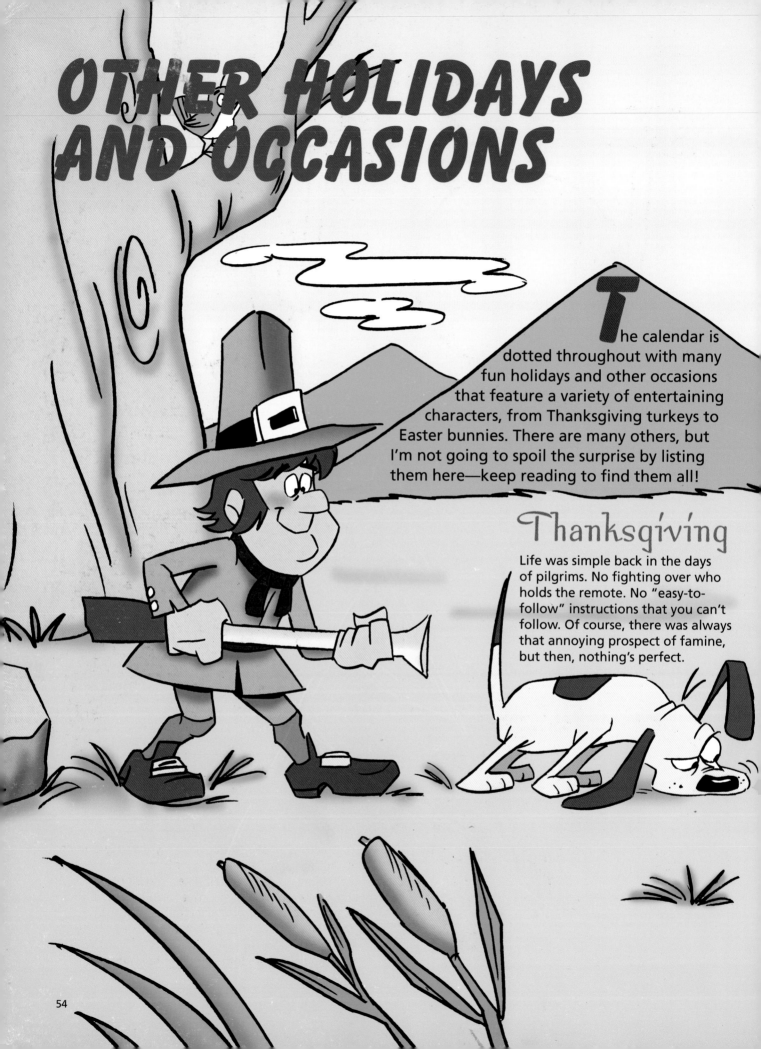

OTHER HOLIDAYS AND OCCASIONS

The calendar is dotted throughout with many fun holidays and other occasions that feature a variety of entertaining characters, from Thanksgiving turkeys to Easter bunnies. There are many others, but I'm not going to spoil the surprise by listing them here—keep reading to find them all!

Thanksgiving

Life was simple back in the days of pilgrims. No fighting over who holds the remote. No "easy-to-follow" instructions that you can't follow. Of course, there was always that annoying prospect of famine, but then, nothing's perfect.

THE HORN OF PLENTY

This is what pilgrims used to carry groceries around in when they ran out of shopping bags. But don't quote me on this. Actually, the cornucopia (a curved horn filled with fruits, vegetables, and grains) is a typical Thanksgiving motif.

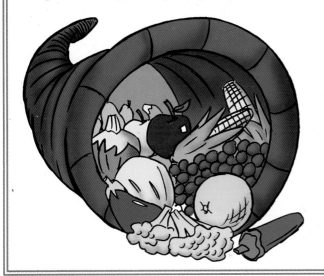

I don't suppose I have to tell you why this guy doesn't enjoy Thanksgiving. If you've ever been to a farm and seen a turkey up close, you'll surely have noticed that this is one incredibly unattractive bird. Its neck and head are scaly. Its body is plump and awkward. It has that weird thingy hanging from its beak. (Why doesn't he get that removed?) And, the legs look worse than your grandmother's. I'm talking ugly.

Pilgrims

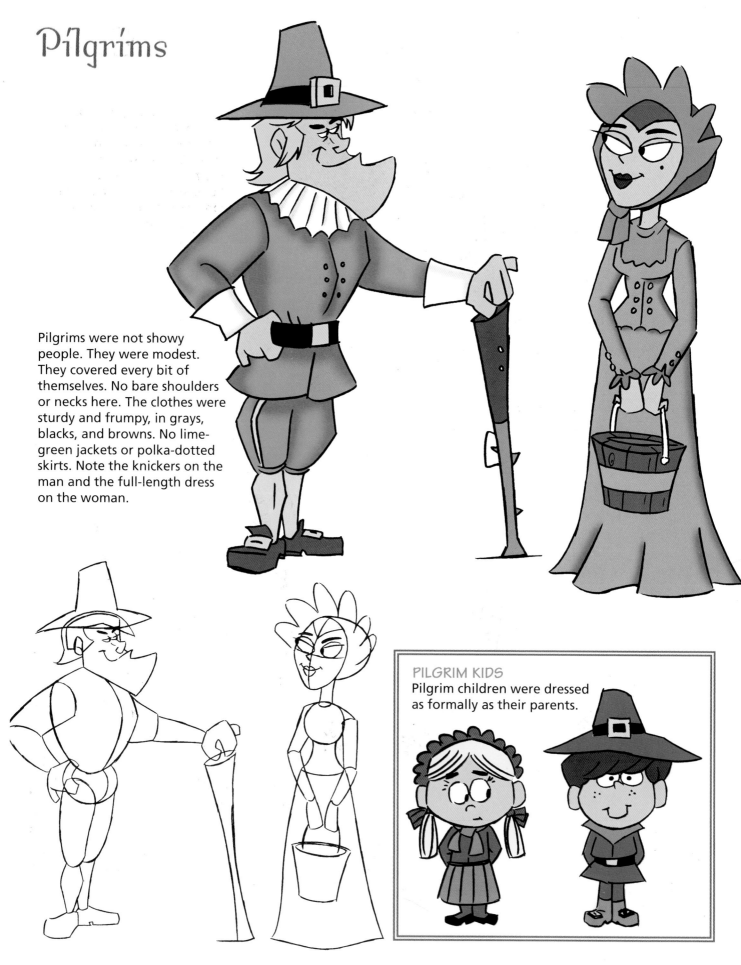

Pilgrims were not showy people. They were modest. They covered every bit of themselves. No bare shoulders or necks here. The clothes were sturdy and frumpy, in grays, blacks, and browns. No lime-green jackets or polka-dotted skirts. Note the knickers on the man and the full-length dress on the woman.

PILGRIM KIDS
Pilgrim children were dressed as formally as their parents.

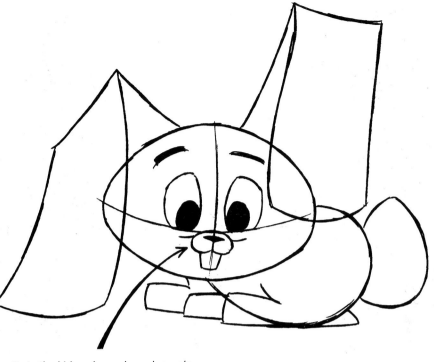

Easter

The Easter bunny is a popular symbol of this holiday. You can probably guess the basic characteristics of a rabbit: buck teeth, bushy tail, and long ears. But don't forget to add extra-long feet, bushy cheeks, and whiskers, too.

Note the kidney bean-shaped muzzle.

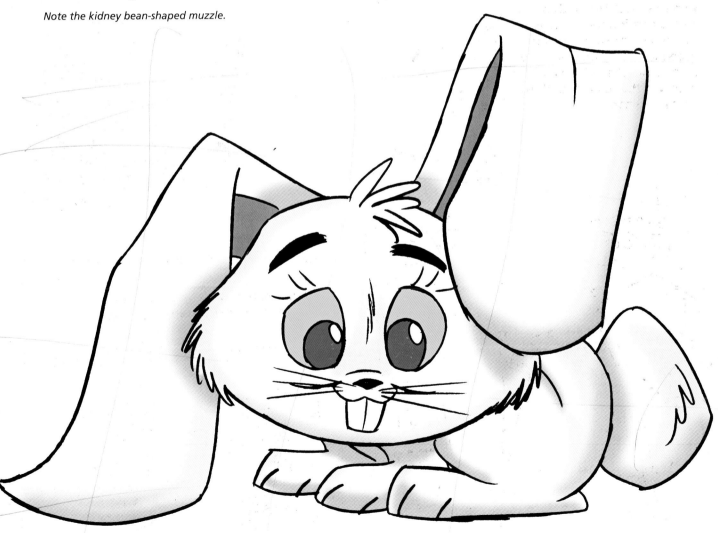

More Easter Rabbits

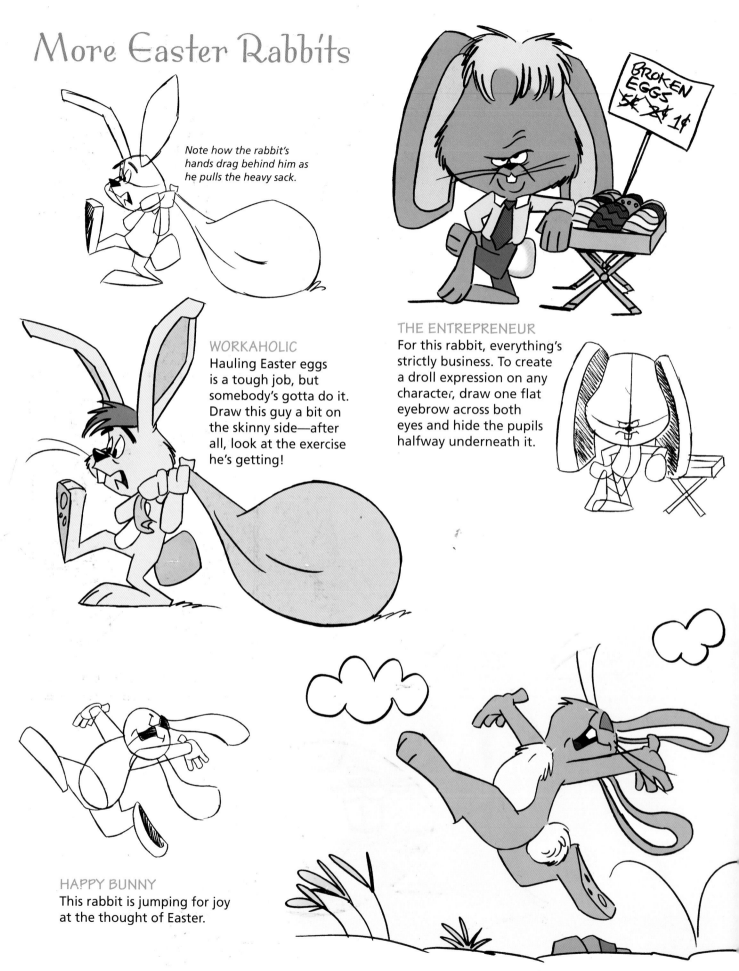

Note how the rabbit's hands drag behind him as he pulls the heavy sack.

WORKAHOLIC
Hauling Easter eggs is a tough job, but somebody's gotta do it. Draw this guy a bit on the skinny side—after all, look at the exercise he's getting!

THE ENTREPRENEUR
For this rabbit, everything's strictly business. To create a droll expression on any character, draw one flat eyebrow across both eyes and hide the pupils halfway underneath it.

HAPPY BUNNY
This rabbit is jumping for joy at the thought of Easter.

There aren't many things cuter than a little chick. People often buy little chicks for Easter, forgetting that the chicks soon grow up to be chickens. And there are lots of things cuter than chickens.

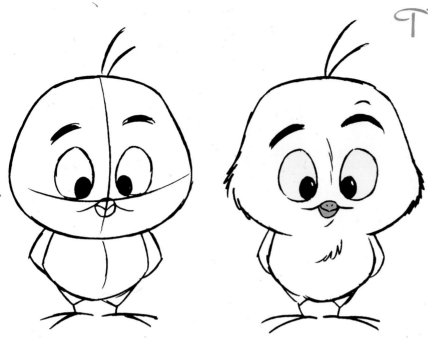

FRONT VIEW WITH BASIC CONSTRUCTION

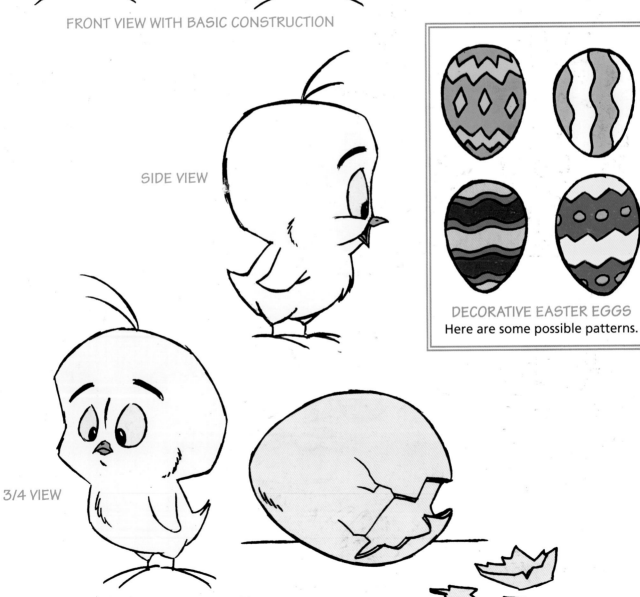

SIDE VIEW

3/4 VIEW

DECORATIVE EASTER EGGS
Here are some possible patterns.

St. Patrick's Day

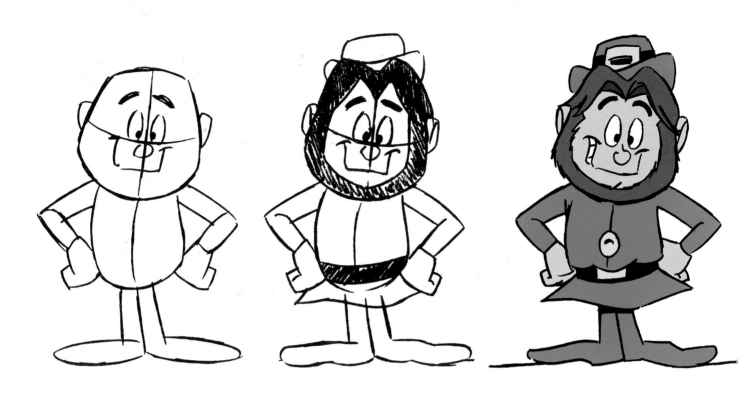

LEPRECHAUNS

Leprechauns are supposed to have a pot of gold stashed somewhere in the woods, but they aren't telling. They're little people (like elves) who always dress in green, have beards, and wear short, round hats with buckles.

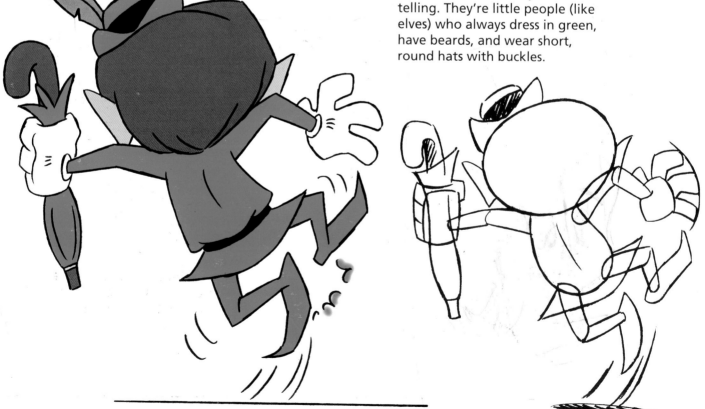

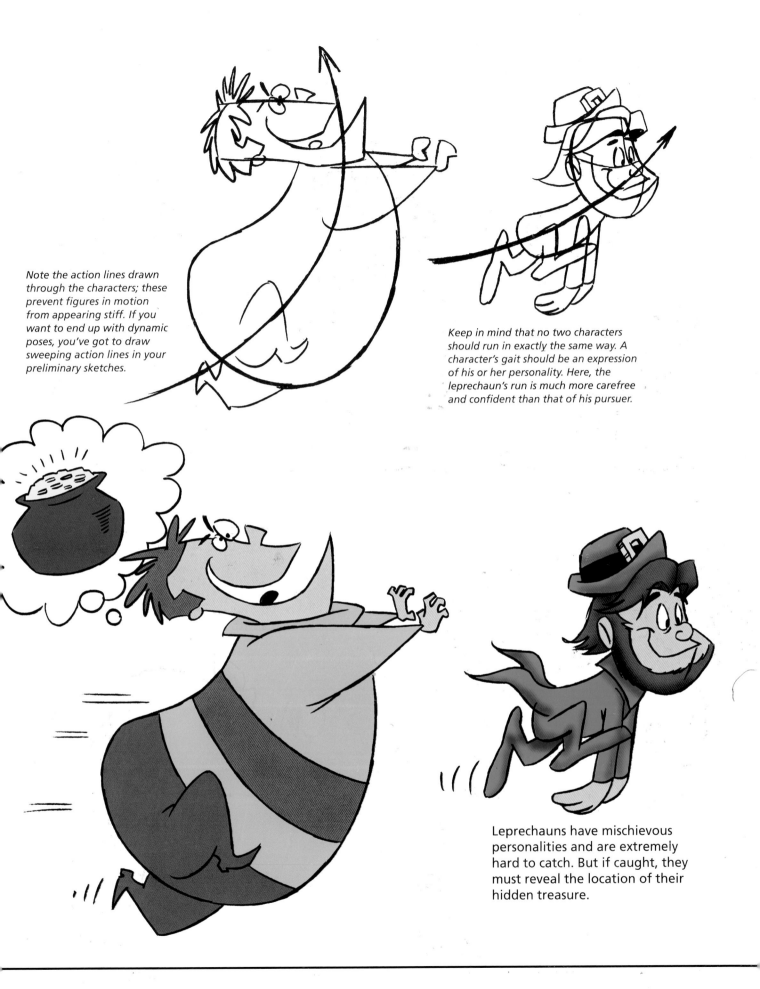

Note the action lines drawn through the characters; these prevent figures in motion from appearing stiff. If you want to end up with dynamic poses, you've got to draw sweeping action lines in your preliminary sketches.

Keep in mind that no two characters should run in exactly the same way. A character's gait should be an expression of his or her personality. Here, the leprechaun's run is much more carefree and confident than that of his pursuer.

Leprechauns have mischievous personalities and are extremely hard to catch. But if caught, they must reveal the location of their hidden treasure.

Valentine's Day

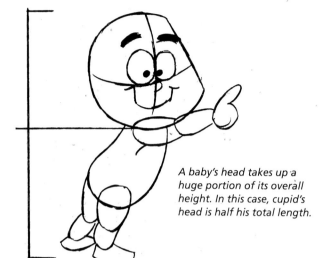

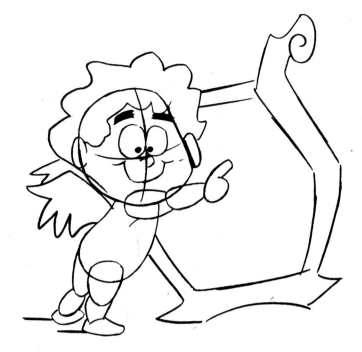

A baby's head takes up a huge portion of its overall height. In this case, cupid's head is half his total length.

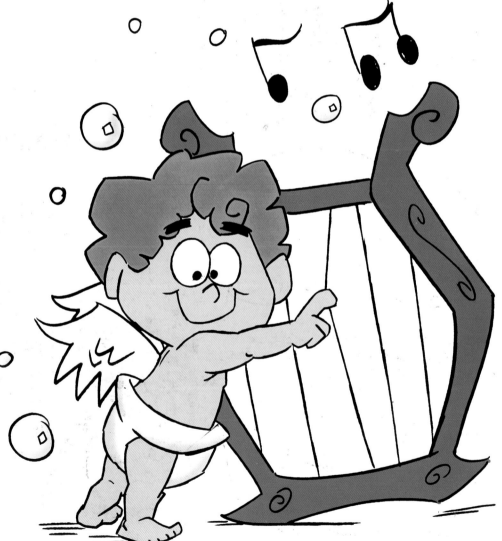

CUPID
Cupid is a chubby male baby with wings. Give him curly hair and a mischievous but good-natured twinkle in his eye. His limbs and tummy must be pudgy, and his eyes should be big.

Groundhog Day

While not an official holiday, Groundhog Day still yields a fun character: the groundhog. The groundhog hibernates in its burrow all winter. Then, as legend has it, on February 2 it opens its groggy eyes and pokes its head out to see if it's spring yet. If the groundhog can see its own shadow, there'll be six more weeks of winter. But if not, spring is almost here.

THE GROUNDHOG
I like to give the groundhog pajamas. It's also important to add big buck teeth and short little whiskers, plus tiny ears and bushy cheeks.

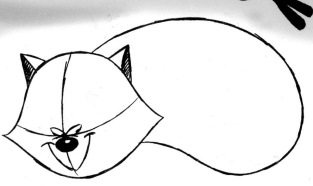

Friday the 13th

Although it's not really a holiday, Friday the 13th is that infamous day when anyone who is at all superstitious tries to avoid all signs of bad luck.

THE BLACK CAT
The most popular symbol of bad luck is the black cat. As the saying goes, if a black cat crosses your path, you're in for it. But it could be worse. If, say, a black cat crossed your path while you were walking under a ladder carrying a broken mirror and stepping on a crack in the sidewalk, that would be really, really bad.

Anyway, this cat should be mischievous and sneaky. How do you show that? Drawing a sneaky expression is one option. But the best way to show that a character is sneaky is to give him or her a "sneak-walk." By artfully walking on tiptoes, this cat exudes a silly, sinister quality.

INDEX

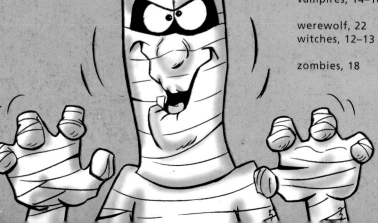